LOST
EDINBURGH

LIZ HANSON

AMBERLEY

Acknowledgements

I would like to thank the following people for their help: Alison Stoddart of Capital Collections at Central Library, David Patterson of City Arts Centre, Historic Environment Scotland, Peter Stubbs of Edinphoto for invaluable assistance, Bill Scott, and Frank Hay.

First published 2019

Amberley Publishing
The Hill, Stroud
Gloucestershire, GL5 4EP

www.amberley-books.com

British Library Cataloguing in Publication Data.

A catalogue record for this book is available from the British Library.

ISBN 978 1 4456 8748 3 (print)
ISBN 978 1 4456 8749 0 (ebook)

Typesetting by Aura Technology and Software Services, India.
Printed in the UK.

Introduction

The topography of Edinburgh renders it unique as a subject for a 'lost' city, having grown up on a mile-long sloping ridge, punctuated at the top by the Castle Rock and at the foot by Holyrood Abbey. To this end, the outline of Old Town Edinburgh is as recognisable today as it was to Oliver Cromwell in 1650 or Charles Edward Stewart in 1745. Superficially, it appears little altered by time and a walk down the Royal Mile captures something of the atmosphere, albeit sanitised, of medieval Edinburgh, with high-rise tenements (known as 'lands') interspersed with narrow, dark wynds and closes. However, in reality, many historic buildings have been lost due to fire, slum clearance, road building and previous insensitivity to the value of conservation. Perspective can be given by the 1742 map of Edinburgh, drawn by William Edgar, which shows 294 closes along the High Street, less than eighty of which remain today.

Once the New Town was born in the eighteenth century, the overcrowded bubble of the Old Town burst, and affluent residents took the opportunity to escape to the clean, airy elegance of the new properties across the valley to the north, leaving the dirt, odours, noise and slums to the poorer citizens.

Undoubtably some buildings were crumbling or unsafe, requiring demolition, but as the expansion of Edinburgh mushroomed, routes were opened between the Old and New Towns which inevitably wiped away large swathes of historic structures. This was particularly ruthless when George IV Bridge and Victoria Street were made, improving the thoroughfare but losing the characterful West Bow in the process. Progress was the priority of this era and it would be another 100 years before the value of preservation was fully realised.

The exodus from Canongate to New Town began a decline in this once fashionable area and by the twentieth century, many dwellings were barely habitable. After a programme of slum clearance and restoration of significant houses, the lower stretch has been catapulted into the modern era with the contemporary Scottish Parliament building which sits comfortably opposite the Palace of Holyroodhouse and the picturesque Whitehorse Close.

Edinburgh manages to carry the passage of centuries through an admixture of architectural styles; one minute, the eye is taken through a dark, cobbled pend, conjuring up ghosts of medieval times, only to be transported the next minute into a bright, modern piazza, representative of the vibrant city that Edinburgh is today. Both Old and New Towns are listed as Unesco World Heritage Sites.

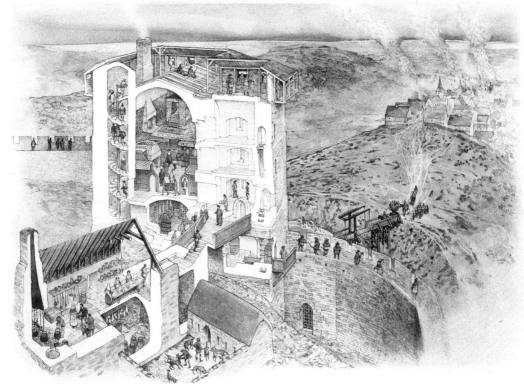

David's Tower

The Wars of Independence between Scotland and England took place during the thirteenth and fourteenth centuries, culminating in victory for Scotland's freedom, but not an end to warfare between the two nations. King Robert I (Robert the Bruce) became King of Scots in 1306 until his death in 1329, when the crown went to his only son, David, who was only five years old. During the Battle of Nevilles Cross in 1346, David was captured and imprisoned in the Tower of London for eleven years. When he returned to Edinburgh, he authorised the erection of a tall tower at Edinburgh Castle, primarily for defence against the continuing attacks on Scotland by the English armies, but also as accommodation. The immense 100-foot structure (located where the half-moon battery stands now) took nine years to build and David died in 1371 before it was completed. By the time of the Seige of Edinburgh Castle in 1573, cannons, rather than longbows, were being used in warfare and a battery of artillery blasted the castle from the far side of the Nor' Loch, eventually destroying it. By this time, the Palace of Holyroodhouse was favoured over the castle as the royal residence. In 1912, archaeologists found subterranean rooms of the tower, with narrow slit windows and so hidden are they that the location was used to hide the Crown Jewels in the Second World War.

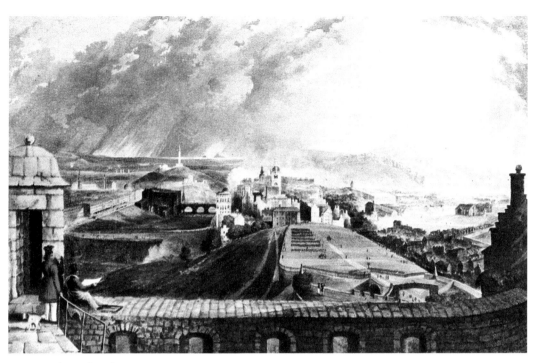

Castle Esplanade

The epicentre of Edinburgh is the volcanic crag of Castle Rock, topped by man-made fortifications and the mile-long tail between this and Holyrood is the foundation upon which the town developed. The uppermost slope in front of the castle, the esplanade as seen these days, dates from the nineteenth century but the approach to the castle was very different in medieval times. The first detailed depiction was done by cartographer James Gordon of Rothiemay in 1647 which showed a castellated wall curving towards the drawbridge and the town walls sloping down Castle Rock to the Grassmarket. By 1660, the castle was no longer a royal residence but the garrison for Scotland's first standing army. When the City Chambers was built in 1753, rubble and earth from that site was used as spoil to level the esplanade to create a parade ground. By this time, an interesting octagonal house called Goose Pie had been built at the very top of Castlehill, overlooking the esplanade and the Nor' Loch, the home of poet Allan Ramsay (now extended to Ramsay Gardens).

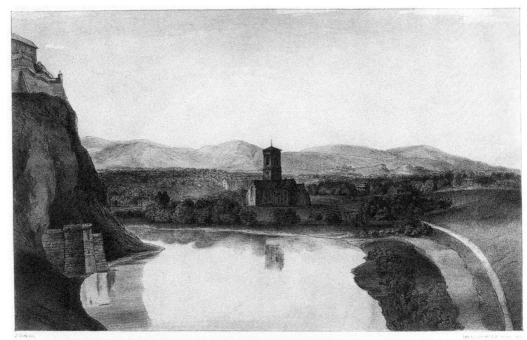

THE OLD CHURCH OF S.^T CUTHBERT AND NORTH LOCH EDINBURGH.

Above and opposite: Nor' Loch

This man-made body of water was created as a northern defence of the castle under orders from James II in 1450 to dam the Craig Burn at the east end of the valley. In the event, the defensive role was never realised because as cannons became popular, they could be fired across the loch, as in the 1573 Seige of Edinburgh Castle and in 1640 when General Leslie's Covenanting army attacked from the grounds of St Cuthbert's Church.

The freshwater loch was not a source of drinking water other than for animals. In the sixteenth century, swans and ducks were introduced for decoration and the Town Council even allocated funds to provide oats to feed to them – killing the birds was punishable by law. Ice skating and boating were both pleasant respites for the residents of the densely populated Old Town.

Nor' Loch was also used for more sinister activities, primarily that of drowning so-called witches during the era of witch trials in the sixteenth and seventeenth centuries, but also for ducking petty criminals who were tied to the dookin' stool. Rubbish tended to be thrown down the slopes from Old Town and effluent was produced by the tanners and fleshers who had small businesses along the south shore. By the time the North Bridge was constructed and New Town development started, the area was no more than a stinking marsh and the decision was taken in 1787 to drain it.

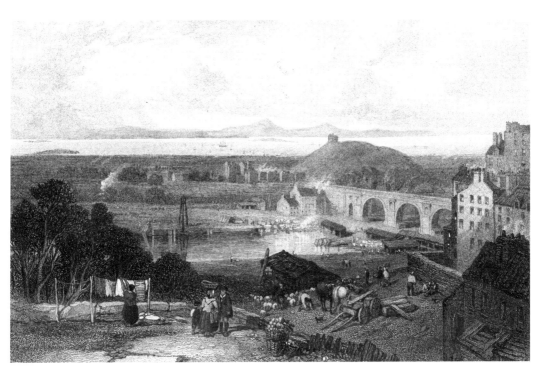

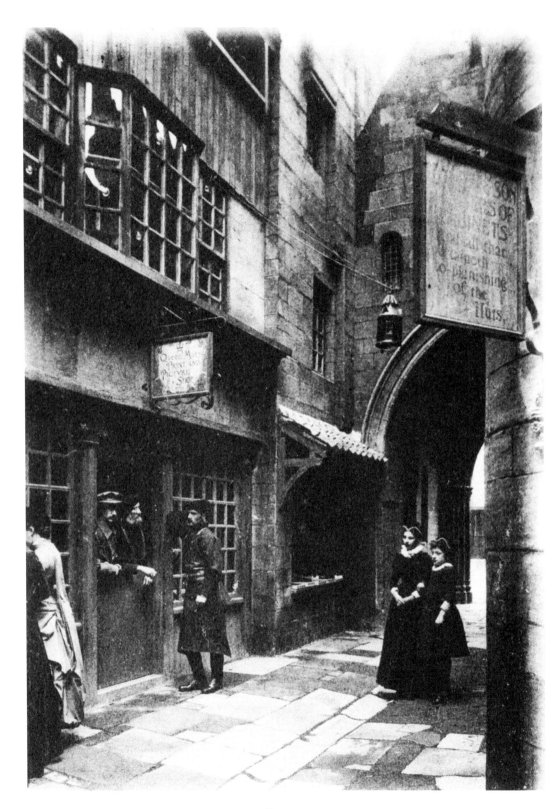

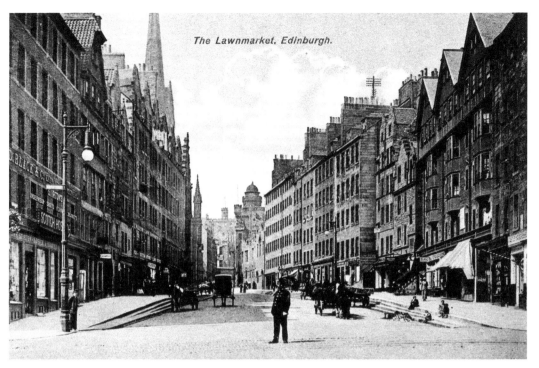

The Lawnmarket, Edinburgh.

Above: Lawnmarket *and opposite*: Mary of Guise Oratory, Castlehill

Mary of Guise was wife of King James V of Scotland and mother of Mary, Queen of Scots. She acted as Regent for her infant daughter between 1554 and 1560 whilst Mary was in France. Her palatial house on Castlehill had been built after the city, including Holyroodhouse, had been burnt by the Earl of Hertford and his troops in 1544, a vicious attack on southern Scotland, known as the Rough Wooing. The dwelling was accessible by three different closes – Blyth's, Tod's and Nairne's – none of which survive today. Oratories were small spaces within houses, specifically used for private devotions, a common practice in the Catholic Church. These tenements had become slum buildings by the nineteenth century and in 1845 were cleared to make room for a new teaching college for the Free Church of Scotland, now known as the General Assembly Hall.

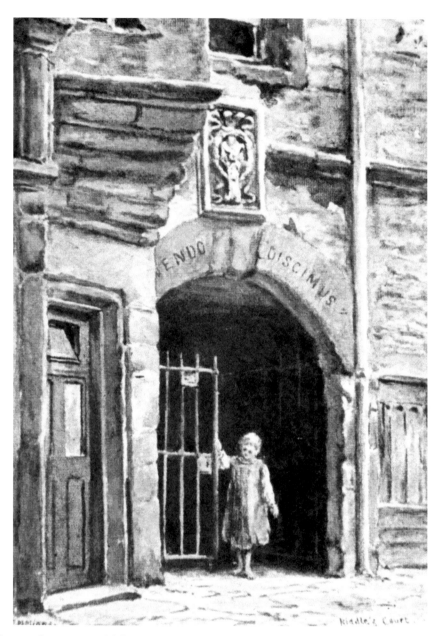

Above and opposite: **Riddell's Close, Lawnmarket**

Castlehill runs into Lawnmarket, the stretch of High Street associated most with trading from shops, stalls and luckenbooths. A few notable closes remain, one of which, Riddell's Court or Close, has been beautifully restored. Most of the wynds, vennels and closes are named after worthy residents of the past and this is no exception. However, the house was built by wealthy burgess Baillie McMorran in 1590 and it was renamed in 1726 when George Riddell reconstructed part of it. There are two courtyards, the inner one being gated and after extension to the outer one, an unusual wooden staircase was erected on the outside wall between the first and second floors, but not connected to the ground level. The Category A listed building has been carefully restored by Scottish Historic Buildings trust.

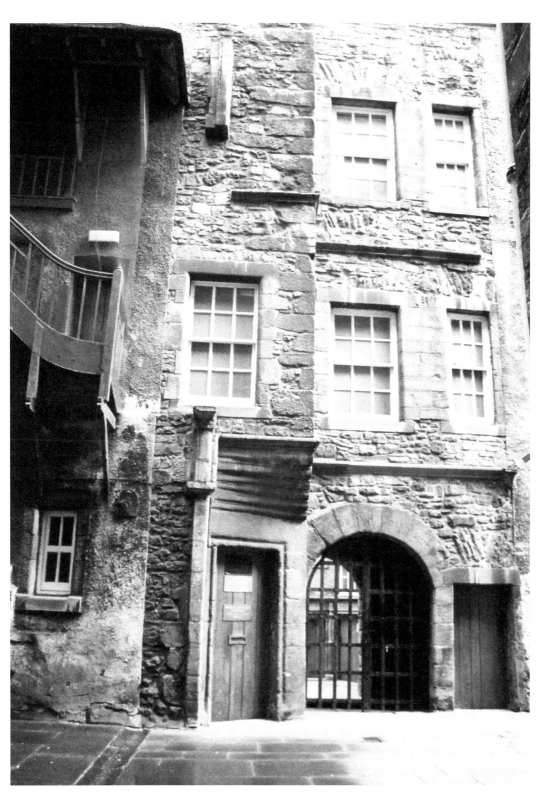

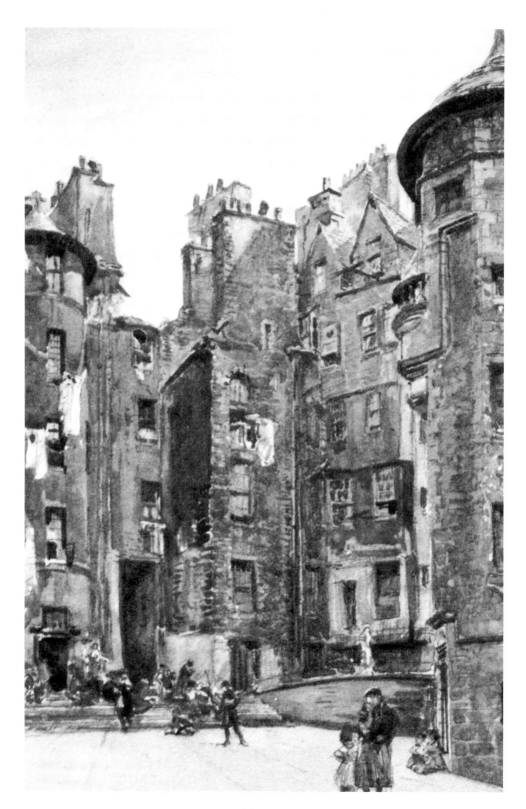

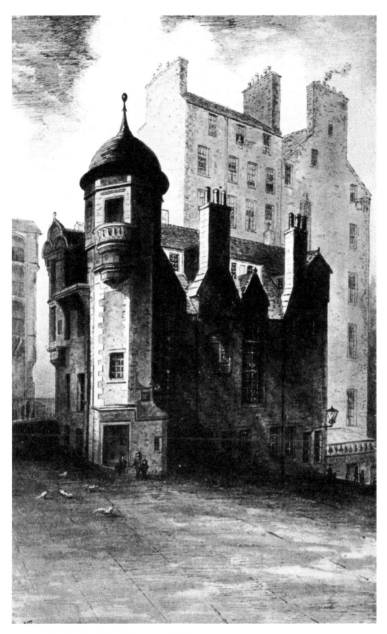

Above and opposite: **Lady Stairs House and Close**

On the north side of Lawnmarket, Sir William Gray built this house in 1622 in Lady Gray's Close but sold it to the widow of the 1st Earl of Stair a century later. At that time, there was a terraced garden at the rear which sloped down to the shore of the Nor' Loch. The painting shows the proximity of overcrowded tenements (or 'lands' as they were known) to the prestigious Lady Stairs House on the right. Gentry lived cheek-by-jowl with the poor, although the upper classes tended to favour the higher floors of the tenements where the smells and noise were less intense. The close was used as a shortcut to the unfinished Mound before Bank Street was made up as part of Edinburgh's improvements. Lord Rosebery, a descendant of Lady Stair, purchased the house in 1893 and, having paid for renovation, gifted it to the nation. It is now home to the Writers Museum.

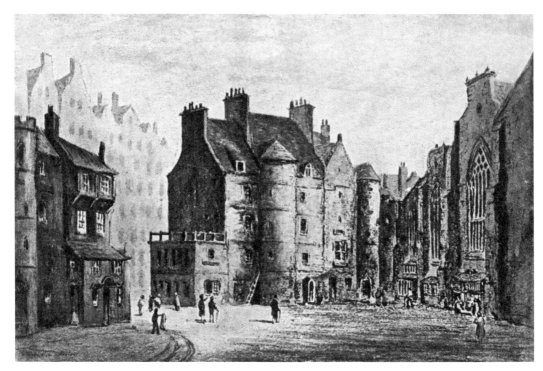

Above and opposite: Old Tolbooth

This interesting building was said to be the most feared destination in Scotland! Tucked in at an odd angle close to the walls of St Giles in Lawnmarket, surrounded by throngs of tradespeople and locals, Walter Scott didn't name it 'Heart of Midlothian' for nothing. In medieval times, the tolbooth served as a meeting place for the Town Council, parliament and the Court of Session as well as a prison. The original building was more like a pele tower (at the eastern end) but was extended in the 1560s and known as the 'new tolbooth'. Once the purpose-built Parliament House was built in 1640, it was used purely for imprisonment; it became a location for executions in 1785 when an extension, topped by a high platform, was added for the purpose. Bizarrely, there were small shops and a tavern beneath this.

The conditions inside the gloomy, cold and stinking jail were dismal, especially for the condemned prisoners who were chained to a bar in cells on the top floor. When their time came, they were led up a narrow, dark, winding staircase from the ground floor to the platform.

The main entrance was in the oldest part of the building near St Giles, adjacent to a small room where the turnkey man resided. When the Old Tolbooth was demolished in 1817, Walter Scott took the heavy wooden door to Abbotsford where he had a collection of Edinburgh memorabilia.

Seen through contemporary eyes, the Old Tolbooth would have made an intriguing addition to Edinburgh's wealth of historic monuments.

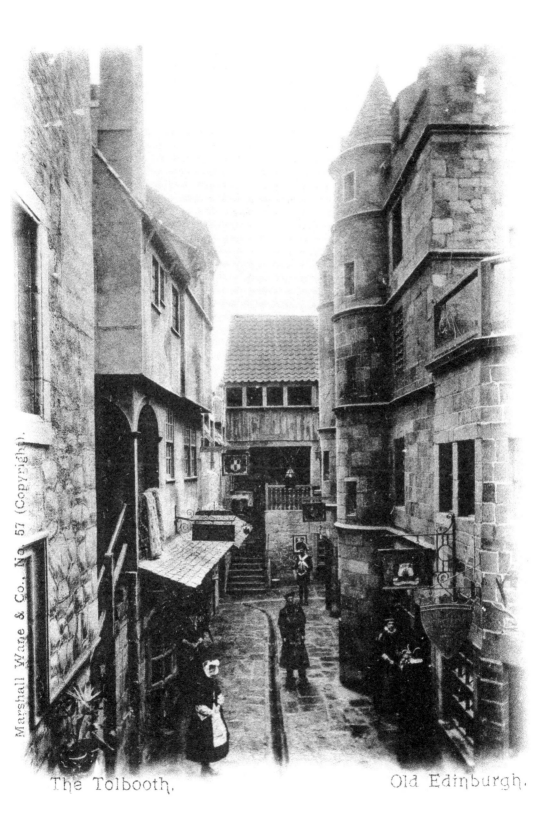

The Tolbooth. Old Edinburgh.

15

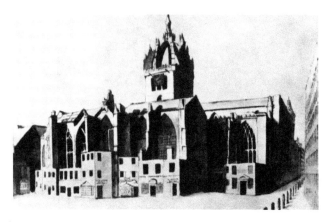

LuckenBooths

These were locked booths from which traders of all kinds sold their goods and a line of them sat in the centre of the Lawnmarket, parallel to, and in front of, the Old Tolbooth and St Giles Church, creating a narrow passageway. These were the luckenbooths proper, and some even had accommodation above them. Others were squeezed in every available nook and cranny against the walls of the kirk (these were known as The Krames). In the early 1600s, the only traders allowed to have wooden booths there were goldsmiths, watchmakers, jewellers and booksellers. The best known of the latter was William Creech, whose step-father had purchased the luckenbooth from Allan Ramsay in 1773 and who sold books there for forty-four years. It was not until 1817 that the luckenbooths were taken down to clear the High Street for increasing traffic.

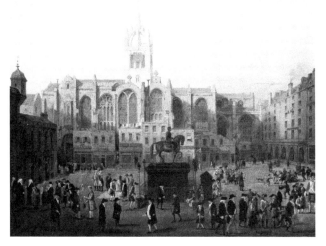

Parliament Close

The sloping ground between St Giles and Cowgate was used as the Burgh's graveyard, overlooked by manse houses for ministers at the Kirk, but the site was deemed suitable for a new Parliament building in 1632. By this time, the nearby Old Tolbooth had become so overcrowded that it could not accommodate Parliament, Town Council, Court and prisoners, and not only was St Giles being used as an overspill meeting place, but the judges were threatening to move the entire Scottish Judiciary to St Andrews. Charles I put pressure on the Town Council to build Parliament House, which was completed by 1640 and used until the Treaty of Union in 1707. Tall tenements were constructed on the east side, creating an enclosure known as Parliament Close, although it was later renamed Parliament Square – an unpopular decision with Edinburgh citizens.

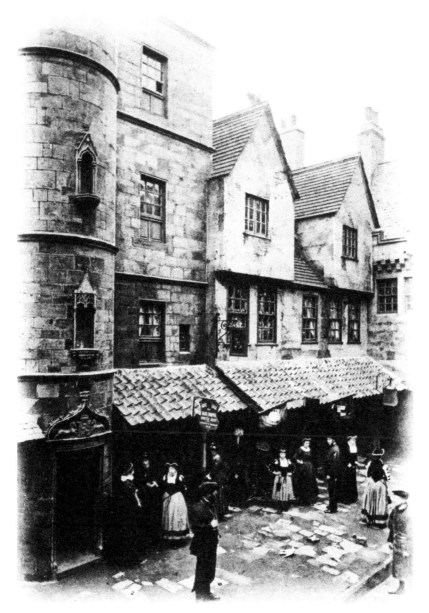

Black Turnpike

This imposing house was built in 1461, just up the hill from the Tron Church, and was considered to be one of the best mansions in the Old Town. It was also known as the 'Auld Bishop of Dunkeld's Lodging'. Mary, Queen of Scots was brought here in 1567 after she had been captured at Carberry Tower before being imprisoned in Loch Leven Castle. At this time, Black Turnpike was home to Provost Sir Simon Preston. The magnificent architecture of the house was in stark contrast to the ugly guardhouse opposite, described by Walter Scott as 'a long black snail crawling up the middle of the High Street and deforming its beautiful esplanade'. The City Guard were stationed here until the inconvenient building was removed in 1785. Where the destruction of the guardhouse was welcomed, that of the Black Turnpike was mourned by Edinburgh citizens, but it was forfeited for construction of South Bridge.

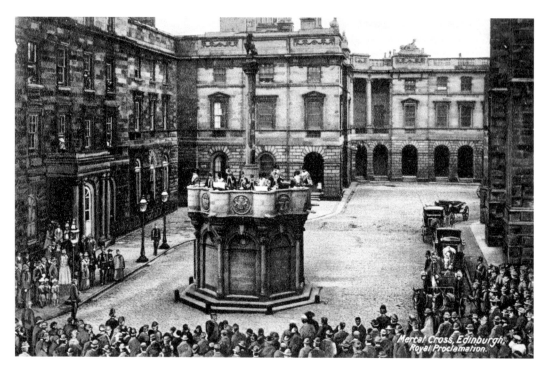

Mercat Cross, Edinburgh,
Royal Proclamation.

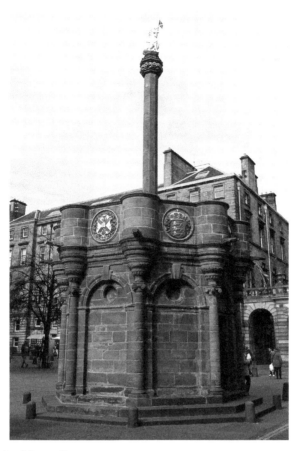

Above and opposite: Mercat Cross

Mercat crosses everywhere attracted gatherings of local residents, catching up on the latest news and gossip, although historically, their official function was to mark the place where the monarch granted towns the right to hold a market on specific days. The charter of 1365 describes the Mercat Cross as being downhill from St Giles. In 1617, it was moved further down the High Street near Fishmarket Close in order to widen the street for the impending visit by James IV of Scotland (James I of England), and this site is marked by an octagon of cobbles. 150 years later when improvements were being made to the town, the cross was considered to be an encumbrance, and, with no sense of historic value at that time, it was rudely handled and broken, an issue that angered Walter Scott, although he procured a few of the medallions for his Edinburgh memorabilia collection at Abbotsford House, Melrose. Luckily, Lord Somerville gathered the pieces and took them to his country estate at Drum where they remained until 1866, when public pressure persuaded the council to repair and reinstate it. Unfortunately, it was placed inside the railings which surrounded St Giles at the time and the enclosure became unsightly due to an accumulation of weeds and litter. William Gladstone, Prime Minister and MP for Midlothian, was instrumental in restoring the cross and reinstating it to a prominent position in the High Street, on the east side of St Giles.

The first proclamation for 150 years was held there in 1901 when Queen Victoria died and was succeeded by her son King Edward VII. Public announcements regarding accessions to the throne or general elections continue to be done here, performed by heralds of Lord Lyon, King of Arms.

In 2018, renovation work was undertaken to repoint the stonework and paint the heraldic decorations and upon completion, a rededication ceremony was held.

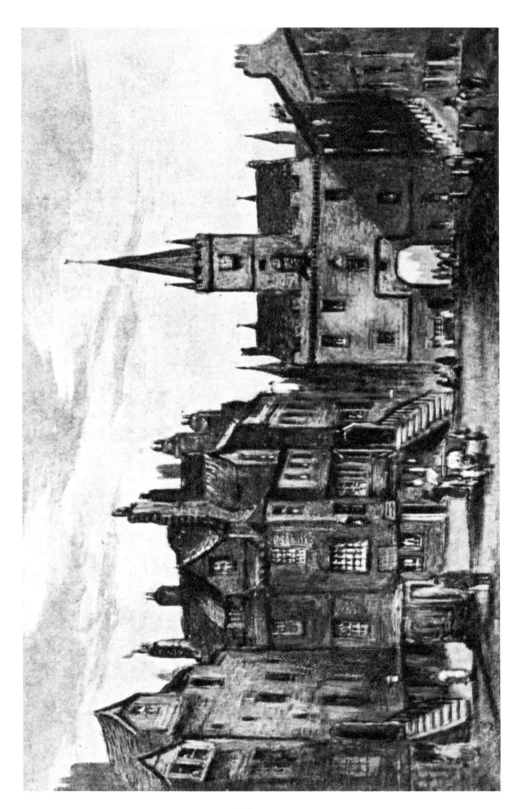

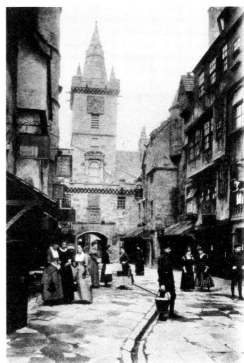

Above and opposite: Netherbow Port

Access into Edinburgh was through one of six ports (gates) in the Flodden Wall. The lesser medieval town wall, known as the King's Wall, was built in 1450 under orders of James II but after the slaughter of the Scots at the battle of Flodden in 1513, defences were strengthened with the higher and longer Flodden Wall. Entrance points were West Port leading to the Grassmarket, Leith Wynd Port, Cowgate Port, Kirk o' Field Port to the south, Bristo Port near Greyfriars and Netherbow Port. The latter, on the High Street, had existed since the fourteenth century and divided the ancient burghs of Edinburgh and Canongate. It was badly damaged during the Burning of Edinburgh by the Earl of Hertford in 1544 and reconstructed in 1571 when the clock tower and spire were added. The picture shows the attractive, ornate structure which included rooms, in one of which was a blacksmith, but also demonstrates the impractical width of the archway for traffic, which ultimately was responsible for its demolition. Nonetheless, it was much loved by the citizens and helped to give them a greater feeling of security in the turbulent sixteenth and seventeenth centuries.

The government exploited the civic pride of the residents in 1736 when they threatened to demolish Netherbow Port as punishment for the Porteous Riots; the Captain of the Town Guard, John Porteous, had been convicted of murdering several people at an execution in the Grassmarket but word spread that the charges were going to be dropped and a mob stormed the Tolbooth, grabbed Porteous and proceeded to lynch him. The beloved gateway survived, but only for another thirty years. It was taken down in 1764, against the wishes of Edinburgh residents, but the traffic bottleneck was eased. The clock was rehoused in the Dean Orphanag – now the Dean Gallery – and the bell lives in the Netherbow Centre. The port is commemorated by an outline of brass cobbles in the High Street placed on the exact site.

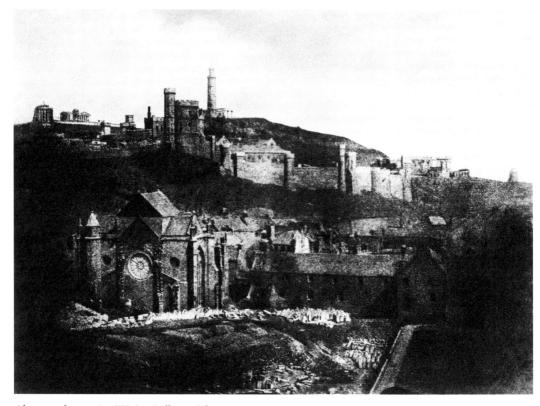

Above and opposite: Trinity College Kirk

This beautiful Gothic church and associated hospital were founded by Mary of Guelders, wife of James II in 1460, who dedicated it to him after his death at the siege of Roxburgh Castle. It was located at the foot of Calton Hill just below the dam at the eastern end of the Nor' Loch.

Waverley Station was in its infancy in the 1840s but the North British Railway was anxious to acquire the land on which Trinity College was situated in order to expand. This caused a public outcry, putting the council in a difficult position. They finally agreed to sell the land but only on the condition that the church be dismantled stone by stone – each of which were to be numbered – and the building reconstructed at a new location. The project was overseen by architect David Bryce and NBR paid £16,000 to cover the rebuilding cost.

A variety of new sites were considered but due to indecision and financial constraints, twenty-five years passed before Chambers Close (between Jeffrey Street and High Street) was chosen, by which time the masonry store had been reduced and many stones damaged, so the resulting new church, completed in 1877, was a poor relation of the original and was partially demolished in 1964. The portion that survived is called Trinity Apse and some numbered stones can be seen in the outer walls.

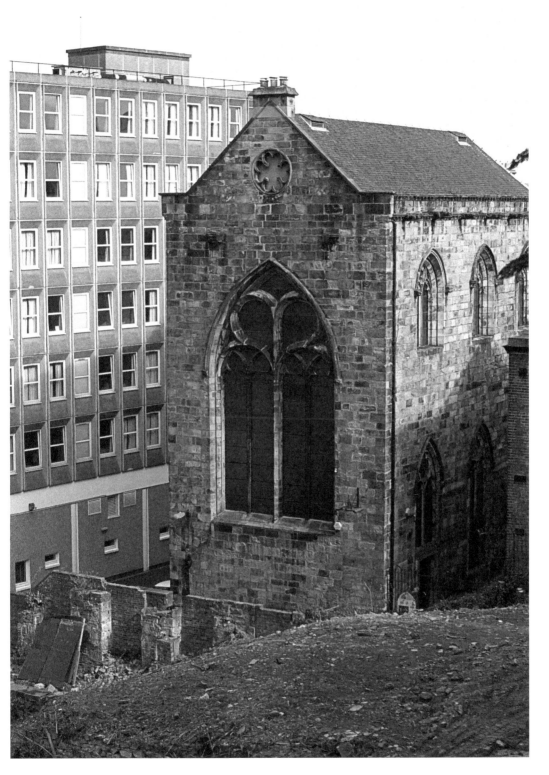

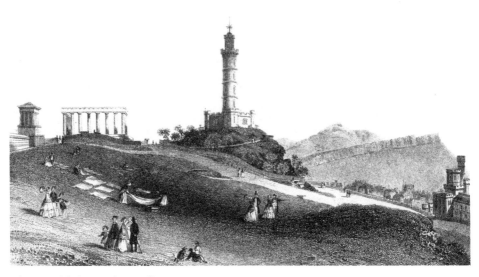

Above and below: Calton Hill

This elevation across the valley to the north of Old Town was used for open-air entertainment, tournaments and sports during the fifteenth century as well as being useful for grazing livestock. On the northern side, above Greenside, was a Carmelite monastery which was deserted before the Reformation and lay empty until 1591 when it was converted to a hospital for lepers – there were gallows near the entrance! Prior to 1609, the Calton land was owned by the Logan family of Restalrig but was forfeited when Robert Logan was charged with treason. Both passed to Lord Balmerino and merged to form one barony. The actual village of Low Calton grew up at the western end of the valley below the hill and was on the old route between the back of Canongate and Leith and it was South Leith Parish Church that villagers worshipped in but the distance to the churchyard was too great to travel with the deceased. A small plot of land was purchased closer to the community, now known as Old Calton Burial Ground. Most of the village was swept away when Waterloo Place was created from 1817. The breezy open slopes of Calton Hill were regularly utilised for beating carpets and drying washing, so were littered with clothes poles and lines.

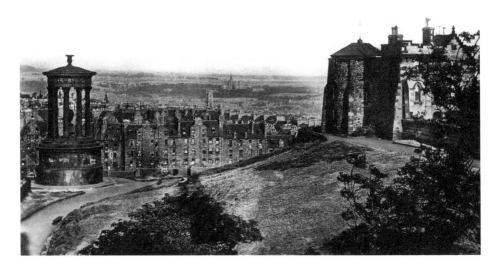

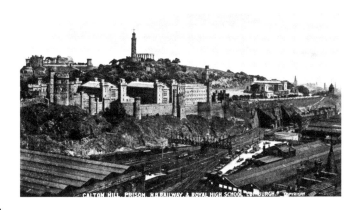

Calton Jail

In medieval times, jails were really only 'holding centres' for criminals until trial. This began to change in the sixteenth century. The Old Tolbooth incarcerated debtors, thieves and political agitators as well as the condemned. By the late 1700s, conditions in the Tolbooth were squalid and its location in the busy High Street was an obstruction to traffic, so a new prison was proposed below Calton Hill, which was built between 1791 and 1796, designed by Robert Adam. By this time, prison reformers had been campaigning for better welfare for prisoners. Bridewell was a generic term for a so-called House of Correction, named after a well dedicated to St Bride, who was said to perform miracle cures. The philosophy of the day was that prostitutes, vagrants, and petty criminals had the potential to be reformed with the correct care and attention. The castellated structure and position were wholeheartedly embraced by Edinburgh citizens to whom the Old Tolbooth was becoming an embarrassment.

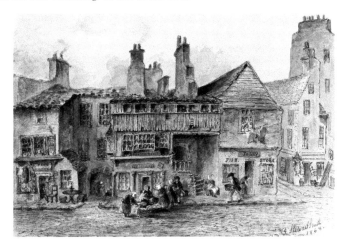

Cowgate

This thoroughfare runs parallel to the High Street but lies in the valley to the south and leads into Grassmarket. Both these areas were outside the original town walls but later enclosed by the Flodden Wall. Cowgate was so named because livestock was brought through this route from the countryside to market. By 1500, most of the High Street and Canongate was built up, so residents, particularly wealthier ones, overflowed into what was seen as an 'up-market suburb' and it became very fashionable in the sixteenth and seventeenth centuries. It is worth noting the architecture of the time; the timber frontages are attractive to our twenty-first-century sensibilities but were very prone to fire damage and were eventually replaced with stone. Andrew Symson, a former Church of Scotland minister from Wigton, opened a printing house at the foot of Horse Wynd around 1697.

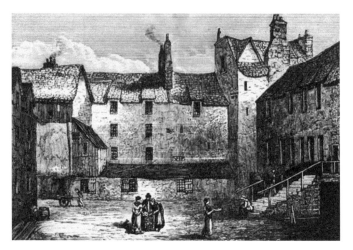

Scottish Mint

The Royal Mint changed locations several times. The first, in the reign of Mary, Queen of Scots, was close to Holyrood Palace and the last, built between 1575 and 1581, was off Cowgate between South Gray's Close and Todrick's Wynd. The offices, workshops and accommodation were built around a courtyard which was enclosed by a high wall and Scottish coinage was minted here until 1707, when the Union with the English parliament made the Pound Scots redundant. The coins were made on the ground floor and finished and polished in an adjoining house. Interestingly, part of the complex was used as a sanctuary for people unable to pay their debts, and a small room on the top floor was even employed as a prison cell for serious debtors.

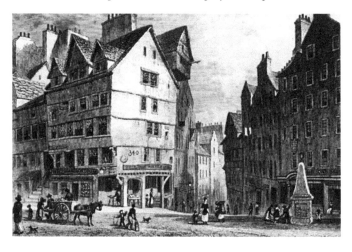

West Bow

The Flodden Wall encircled the suburb of Grassmarket, which was entered through its West Port. The route then climbed into Lawnmarket up a very steep, narrow, winding lane called West Bow, just wide enough for carts to pass. It was an atmospheric street, lined with tall 'lands' in which lived many colourful characters. The most famous of these concerns the strange man Major Weir who lived in West Bow with his sister and was said to walk at night, wearing a cape and always carrying his 'magic' cane that could be seen on its own, preceding him! Locals thought he possessed supernatural powers and both he and his sister were executed, having been found guilty of witchcraft. Their house lay empty for many years. Only the lower part of West Bow remains, continuing as Victoria Street, as a result of realignment to make the George IV Bridge.

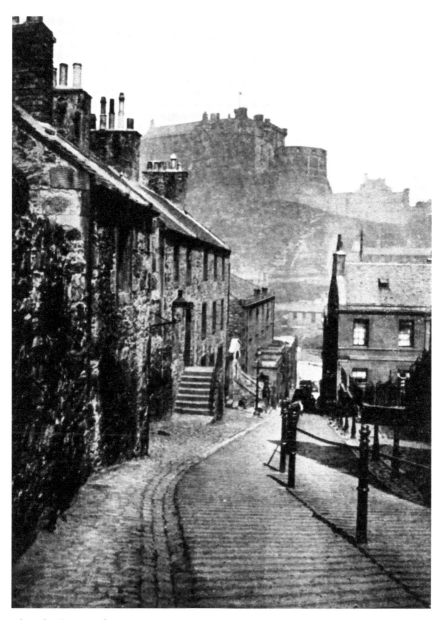

Vennel to the Grassmarket

This old footpath from Lauriston Gardens follows the line of Flodden Wall, a portion of which is still intact here. At the foot of the steps where it enters the south side of the Grassmarket, many of the houses had become dilapidated and unsafe by the middle of the nineteenth century, necessitating demolition. Some of these were known as the Temple Tenements, dating from the sixteenth century and notable for having iron crosses nailed to their doors. Nearby Tanners Close was where a sleazy boarding house was run by William Burke and his wife – he had come from Ireland to seek work on the construction of the Union Canal. William Hare, another Irishman, came to lodge there and their dreadful teamwork began when a guest died in the house. They heard that Dr Robert Knox was willing to pay for freshly deceased bodies for anatomical research and began their murderous moneymaking venture.

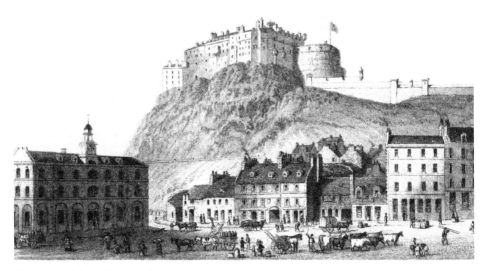

Above and below: Grassmarket

From 1477 this was the location for weekly cattle and horse markets in Edinburgh, the animals being driven along Cowgate from the surrounding countryside to Kings Stables Road at the west end of Grassmarket because cattle were forbidden within the city walls. There was also a large building used for a corn market at the western end, which was abandoned in 1650 in favour of the Corn Exchange at the opposite end. Traditionally, Grassmarket was a lively meeting place with an abundance of inns lining the open cobbled square, but from 1660, the mood became more sombre when the Grassmarket became the official place of public executions. During the period between 1662 and 1668, more than 100 Covenanters were hanged there then dismembered and their heads put on spikes at the West Port as a deterrent to others. In 1937, a memorial plaque was placed on the site of the gibbet inscribed with the names of those who died during what came to known as The Killing Time.

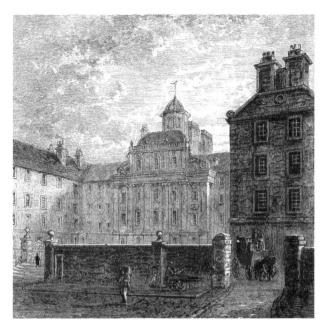

Above and below: Royal Infirmary of Edinburgh

By 1700, the population of Edinburgh had reached 50,000 in the desperately overcrowded Old Town. Their waste, along with that of their pigs, littered the streets and narrow closes making for an unimaginably insanitary environment where sickness was rife, especially among the poor. The idea of providing a Hospital for the Sick Poor was first mooted in 1721 and over the next few years, a fundraising campaign led by the Royal College of Physicians and the Church of Scotland gathered sufficient donations to rent a small four-bedded house in Robertson's Close for the purpose. In the first year, thirty-five patients were treated free of charge and very quickly, the numbers of consultations increased. It was apparent that larger premises were urgently needed and Lord Provost, George Drummond, was instrumental in the public appeal, which attracted huge support. George II awarded a charter to the infirmary in 1736.

The new Royal Infirmary of Edinburgh opened near to the original hospital in what is now named Infirmary Street in 1745, with 228 beds.

In the 1830s, the former Royal High School was converted to a surgical hospital, which was replaced in 1853 by a new one in Drummond Street.

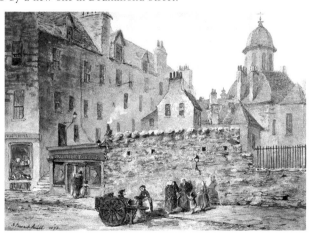

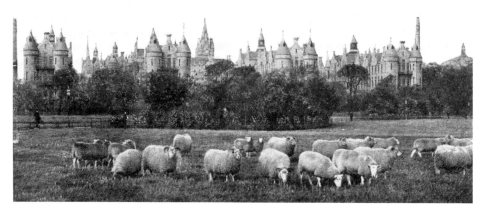

Above and below: Royal Infirmary, Lauriston Place

In 1872, architect David Bryce was commissioned to design a new hospital with consideration given to pavilions for fresh air – therapy pioneered by Florence Nightingale. The site chosen in Lauriston Place was on elevated ground above the Meadows, therefore benefiting from bracing air, unlike the confined space in Old Town. The impressive complex of buildings incorporated George Watson's Hospital (schools were traditionally called hospitals), which had relocated to Archibald Place and was described as 'probably the best planned hospital in Britain'.

The twenty-first century found the Victorian structure wanting and the fourth Royal Infirmary was built at Little France by 2002.

Frontages of the old building have been retained in a modern multi-use project called Quartermile.

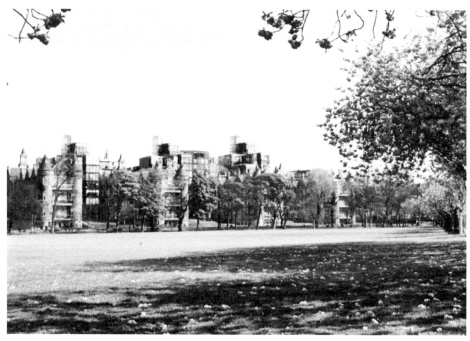

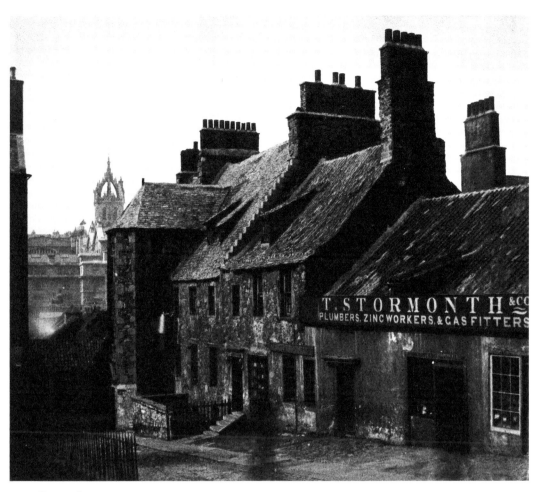

Brown Square

In 1764 enterprising builder James Brown developed a discreet plot of land between Greyfriars Church and the rear of the Excise Office in Cowgate into a square of houses. Part of the land was a bowling green, known as Thomson's Green, named after the man who rented it. The small but elegant mansions were considered very desirable because the style of dwelling was novel and a refreshing contrast to the claustrophobic 'lands' (tenements). He went on to develop George Square. The Edinburgh Improvement Act of 1867, put forward by Provost William Chambers, proposed removal of part of Brown Square, together with all of Argyle and Adam Squares to create Chambers Street, which was carried out in 1870. The southernmost end survived until the 1960s when it was cleared away for an extension to the Royal Scottish Museum, although the 'gap site' remained for many years until the National Museum of Scotland eventually filled the space, opening in 1998.

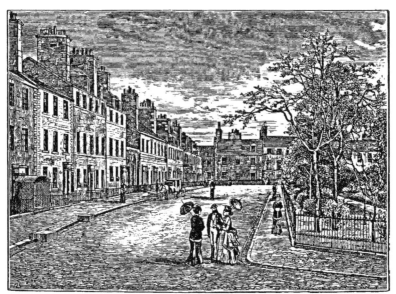

GEORGE SQUARE, SHOWING HOUSE (SECOND ON THE LEFT) OF SIR WALTER SCOTT'S FATHER.

Above and below: George Square

James Brown sought to capitalise on his successful venture in Brown Square and in 1766 he approached the council about purchasing 26 acres of ground surrounding the Ross Park mansion, just outside Bristo Port. He named it after his brother, George, who is credited with the idea. It cost £1,200 but it was a shrewd move because the resulting quadrangle of terraced Georgian houses were quickly inhabited by the upper stratum of Edinburgh society. This proved to be the turning point for the Old Town as George Square was the first significant housing development outwith the town walls. Amongst the luminaries who moved there were Walter Scott, Jane Carlyle, Henry Dundas and the feared judge Lord Braxfield. The popularity was soon eclipsed by the New Town, which attracted the wealthier citizens like a magnet in the early nineteenth century.

Hundred years later, George Watsons Ladies' College was added to the north side of George Square, followed by radical (and controversial) redevelopment in the 1960s when the modern university library, designed by Basil Spence, filled the southern quarter.

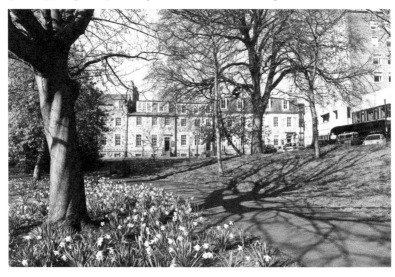

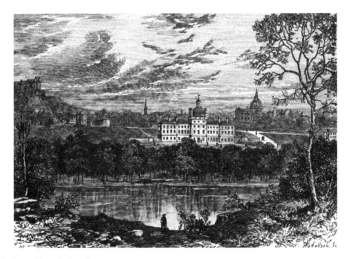

Above and below: Burgh Loch

The green area of parkland now known as The Meadows was once the Burgh, or South Loch which filled the low-lying ground between Edinburgh and the wooded ridge of Burgh Muir. In 1598, the Society of Brewers was founded by James VI and several breweries operated on the eastern side of the loch. The water supply, which was infinitely cleaner than that of the Nor' Loch, was pumped out with the help of a windmill, but by 1619 the water level had dropped considerably. In 1657, the Town Council drained it, apart from retaining a water hole for horses, and it remained this way until Thomas Hope of Rankeillor purchased the land. This public-spirited man decided to turn the marsh into an ornamental park, during which time the area was closed off. The council requested that a temporary walkway could be constructed across the centre ... and so began Middle Meadow Walk, which opened in 1743.

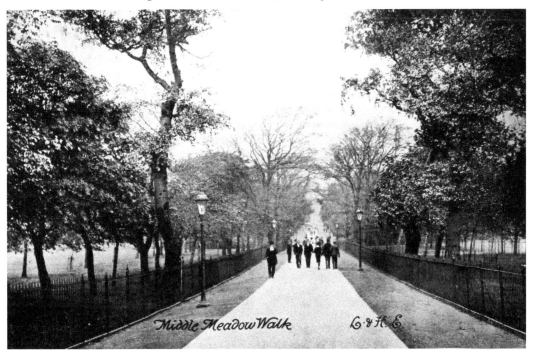

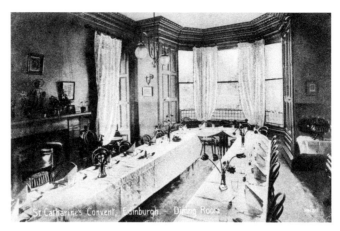

St Catherine's Convent

St Catherine's opened in 1860 at the western end of Lauriston Gardens, a few years before the Royal Infirmary was built at the other end of the street. It is named after Mother Catherine McAuley who founded The Sisters of Mercy in Ireland, to care for the destitute. Today it is used as a support centre for the homeless and those in need. A small Dominican convent of the same name, devoted to St Catharine of Sienna, existed in the Sciennes area in the early sixteenth century and was run by aristocratic ladies who had been widowed after Flodden. It was burnt during the Rough Wooing in 1544 and then completely destroyed after the Reformation.

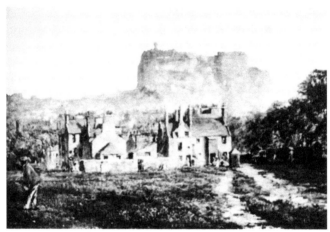

The old village of Wrychtishousis

Wrychtishousis

This property was the ancient home of the Napier family and was situated close to modern-day Gillespie Crescent. The fourteenth-century peel tower, known as Burgh Muir Castle, was extended into a splendid baronial pile, partly castellated and adorned with carved stone pediments. It was demoished in 1800 and James Gillespie Hospital built on the site. The curious name was possibly derived from 'wrights' houses'. The adjacent Burgh Muir was wooded and the small community around the estate would have included woodworkers and carpenters (wrights). In 1508, James IV issued a charter to clear trees from Burgh Muir which had become a hideout for vagabonds and criminals – he allowed Old Town residents to extend their accommodation by adding wooden frontages, creating extra room to their cramped living conditions. The village of wrights' houses was cleared away when the road from Tolcross to Morningside was laid down and was situated near the Golf Tavern.

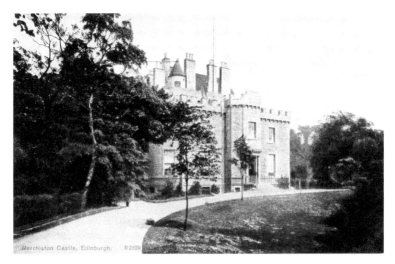

Merchiston Castle, Edinburgh. R2929

Merchiston Castle

Another south-side mansion was the fifteenth-century Merchiston Tower, which belonged to Alexander Napier, whose grandson, John Napier, was responsible for inventing the mathematical system of logarithms in 1614. He was the first person to conceive the notion of decimal points, earning him the nickname the 'wizard of Merchiston'. In 1935 the property was sold to Edinburgh Council, who spent six years restoring the tower before developing a technical college complex around it. Napier Technical College opened in 1964 and in 1992 achieved university status.

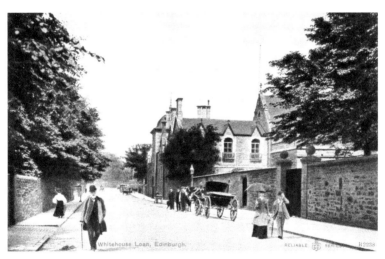

Whitehouse Loan, Edinburgh. RELIABLE SERIES R2238

Whitehouse Loan

The rural environs of Burgh Muir were favoured for isolation of victims of plague, which spread quickly in the confined, airless and unhygienic conditions in Old Town. When the Great Plague struck in 1585, the owners of large houses in the area were obliged to quarantine the sick. The Whitehouse mansion was occupied by Lady Cliftonhall, who vehemently objected to the victims being in her home and won her case against the council. However, five years later, the very same lady was found guilty of witchcraft and burnt at the stake on Castlehill. The building became known for better reasons in 1834, when the first post-Reformation convent was founded there by Revd late Bishop James Gillis. St Margaret's Convent is now a theological administrative centre and library, renamed the Gillis Centre.

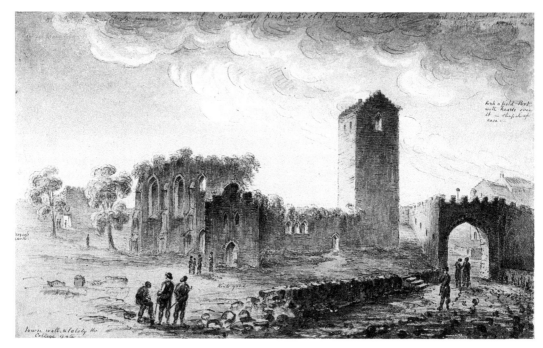

Above and opposite: Kirk o' Field

South of Cowgate was an ecclesiastical area where the Dominican monastry of Black Friars was contiguous with the grounds of the Church of St Mary in the Fields (known as Kirk o' Field), both of which lay outside the King's Wall but were later enclosed within Flodden Wall. After the Reformation, they were attacked and largely destroyed, although some of the associated buildings at Kirk o' Field were repaired and used for teaching. In 1853, they were rebuilt to form the College of St James, which developed into the Old College of Edinburgh University with the erection of Robert Adam's building of 1789.

The Kirk o' Field however, is ubiquitous in Scottish history books as the place where the second husband of Mary, Queen of Scots was murdered. In 1557, Lord Darnley, purportedly suffering from smallpox, had temporarily moved out of Holyrood Palace into domestic accommodation in the church grounds in order to protect their infant prince, James, from infection. In the small hours of the morning there was a huge explosion and his body, together with his servant, were found in the orchard beside Flodden Wall. The prime suspect was the 4th Earl of Bothwell but he was acquitted, although five of his associates were executed. It remains one of the most intriguing unsolved mysteries of Scotland.

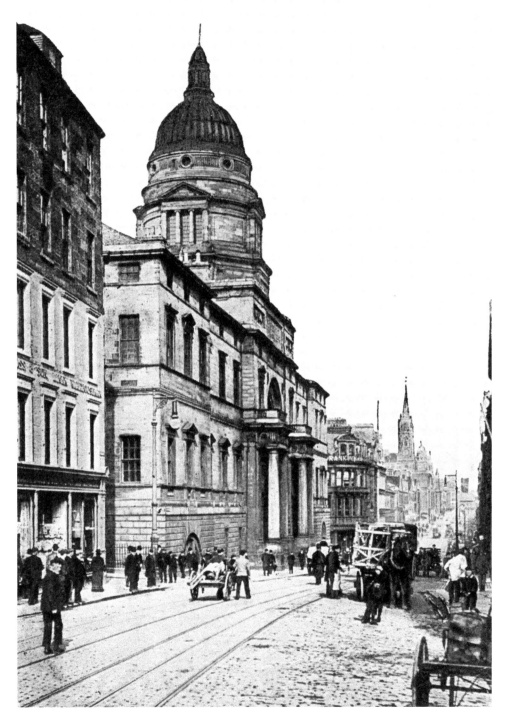

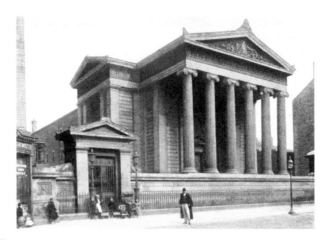

Surgeons' Hall

In medieval times, surgeons were classified with barbers, both professions requiring sharp instruments to practice, and in 1505 the Incorporation of Surgeons and Barbers was started. Despite the best efforts of the medical fraternity, this situation continued until 1722 when the first Chair of Anatomy was created. Initially, they met in rooms in a tenement in Dicksons Close, then moved in 1697 to the more spacious Old Surgeons' Hall in High School Yards. At the turn of the eighteenth century, larger premises were needed, partly to accommodate the large collection of pathological specimens. The site of the Royal Riding School in Nicholson Street was chosen and the eminent architect Henry Playfair designed the present Surgeons' Hall, which has subsequently been extended since this photograph of early 1900s.

Canongate

This was a separate burgh from Edinburgh, having been granted the status of Burgh of Regality by King David in 1128 and named Canongate after the Augustinian canons of Holyrood Abbey. Until the Reformation in 1560, the abbey was used as the parish church, after which Canongate Kirk was built. The historic façades seen on both sides of the street hide the huge changes that have occurred in Canongate over the last two centuries. The proximity of the royal court at Holyrood made Canongate popular with aristocracy and wealthy merchants, who could afford to use stone for their houses. The only examples of sixteenth-century properties remaining in Canongate are the Tolbooth and Huntly House. A good deal of aristocrats lived in Canongate in the eighteenth century but the attraction of the New Town reduced their numbers, although the numerous local industries kept the lifeblood flowing. Then, in 1817, a new road was built along the foot of Calton Hill which allowed traffic from the east to bypass the Canongate thoroughfare, which was another nail in its coffin.

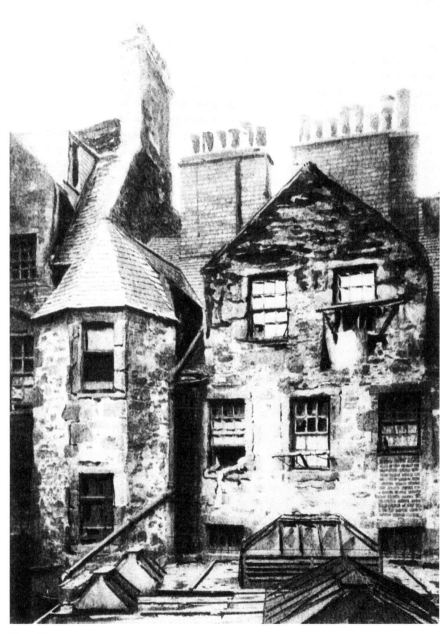

St Johns Close

A second cross – St John's Cross – was located at the top of the hill in Canongate. Although it was just outside the town wall, the Edinburgh authorities considered that they had jurisdiction over the land between the Cross and Netherbow Port and dignitaries gathered around it before entering the Old Town. The spot on which it stood is marked by a St John's Cross. The name is thought to date back to the Middle Ages when the Knights of St John of Jerusalem owned the land there. In 1760s, three- and four-storey tenements were built in what is now St John's Street, with an entrance through a wide pend; apart from No. 1, these have all been demolished.

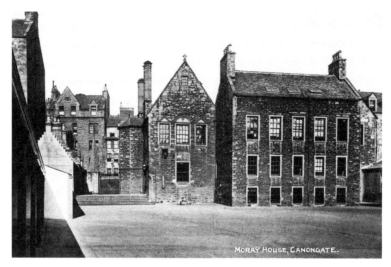

Moray House

The frontage of the 1618 mansion has altered little from the time it was owned by Mary, Countess of Home, and retains the infamous balcony from which, in 1650, the Argyll family wedding party peered down (and spat) upon their enemy, the Marquess of Montrose, who had been captured in Ardvreck Castle by covenanting sympathisers and was being taken to be hanged on the Burgh Muir. However, the south-facing land behind was cultivated and developed by the countess into a magnificent garden, known as 'Lady Home's Yard', famous for its terraces planted with fruit trees. The summer house, which still exists, was open to the public at times, an early pioneer of Scotland's Garden Scheme, and was the place where the Treaty of Union was signed in 1707. In the early nineteenth century, the Cowan family lived in Moray House and restored the garden and orchards, even adding water features to the lower terrace.

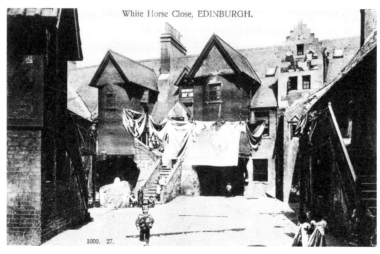

Whitehorse Close

This photograph was taken in the early 1900s, two centuries after the famous inn at the rear of White Horse Close was the departure point for London, and portrays the squalid living conditions endured by residents of Canongate slums. During the 1950s, the City Council started a programme of slum clearance in Canongate but thankfully chose to restore White Horse Close, which is the 'prettiest' of all on the Royal Mile.

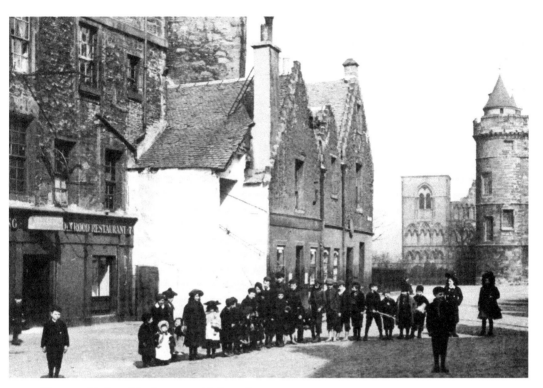

Above and below: The Sanctuary, Holyrood

In the early 1500s, when James IV was King, petty criminals, and particularly debtors, were treated very harshly, both by the debt collectors and the judiciary and potentially in danger of being hanged. Holyrood Abbey and the surrounding park (5-mile circumference) offered religious sanctuary from civil law to those pursued. It was possible to apply to Abbey Baillie for indefinite protection, in which case, the debtors were given accommodation in these gatehouse buildings on Abbey Strand. In 1880 parliament passed a law whereby debt was no longer punishable by imprisonment. At the entrance to Holyroodhouse is a line of letter 'S's' marking the boundary of the sanctuary land.

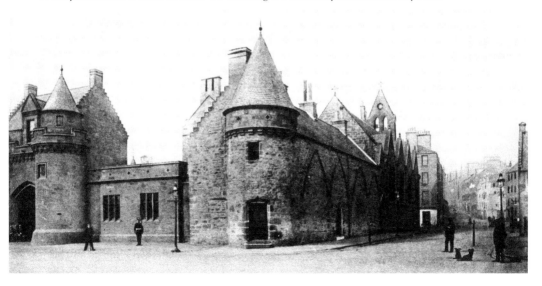

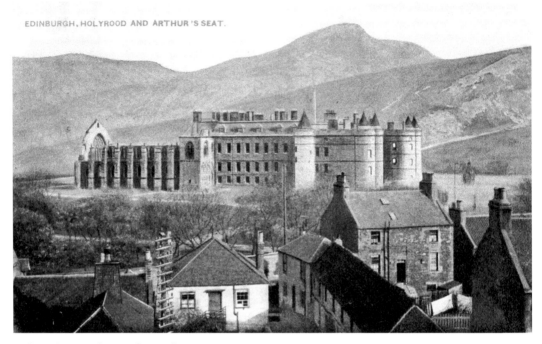

Holyrood House from Calton Hill

The foreground houses illustrate the clutter of dilapidated houses at the foot of Canongate at the beginning of the twentieth century. The backlands on the northern side were densely populated with poorer residents, whilst the sunnier south side was favoured by the aristocracy. The Augustinian Abbey, founded in 1128, offered guest accommodation to royalty as an alternative to the castle but it was James IV who, in 1503, decided to build a proper palace adjacent to the abbey. During the next 100 years, the edifice witnessed much blood and tears including the burning of Edinburgh by the English in the 1540s and the famous murder of the confidante of Mary, Queen of Scots, David Rizzio. The Union of the Crowns in 1603 meant that the king, James VI, moved to London and Holyrood Palace was unoccupied for some decades. Oliver Cromwell's army used it as barracks in 1650 but left it damaged by an accidental fire. Charles II renovated it in 1670 and new royal apartments were added, but after the Act of Union in 1707, the principal functions of the palace ceased and it was neglected. George IV visited Edinburgh in 1822 and ordered that the palace should be repaired and subsequently it was used when royalty came to Edinburgh. To this day The Palace of Holyrood House remains the official residence in Scotland for visiting monarchy.

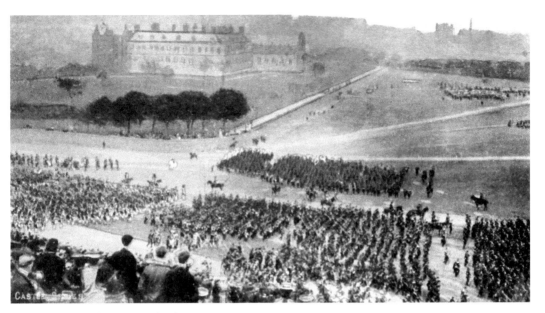

Above and below: Roayl Volunteer Review

The Volunteer Movement (1859–1908) was formed to protect the homeland against a perceived threat from France, while the regular army were fighting for the British Empire. There was great enthusiasm in Scotland for the movement, particularly in the far north, illustrated by 40,000 spectators turning out in pouring rain in 1860 to watch Queen Victoria inspect the parade. The 1905 Review, shown here, was led by King Edward VII but was notable for the attendance of the newly formed Motor Volunteer Corps, who offered four-wheel support to the generals and their staff, who were only familiar with the four-legged variety.

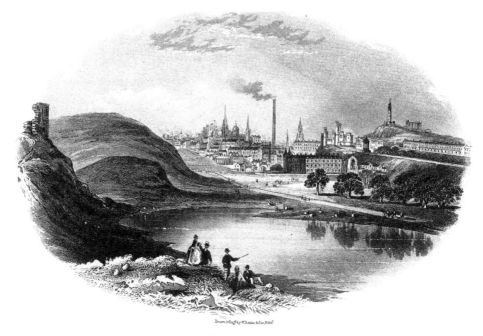

EDINBURGH
from St Margarets Loch

Above and below: St Margaret's Loch

The most prominent feature of the picture above is the inordinately high chimney belonging to the gasworks in Canongate. The royal hunting park was created by James V in 1541, who ordered a stone wall to be built to enclose Arthur's Seat, Salisbury Crags and Duddingston Crags. The 640-acre amenity proved to be a beneficial legacy to the citizens of Edinburgh as well as royalty. Queen Victoria and Prince Albert were fond of visiting Holyrood and he was responsible for the shallow skating and boating pond, known as St Margaret's Loch, to be made in the boggy hollow beneath Whinny Hill.

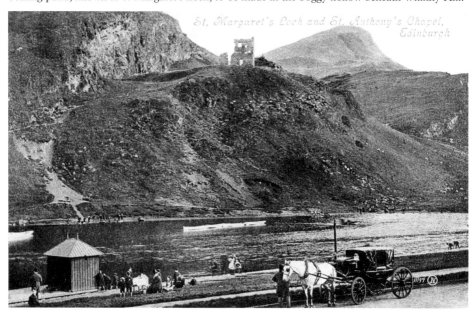

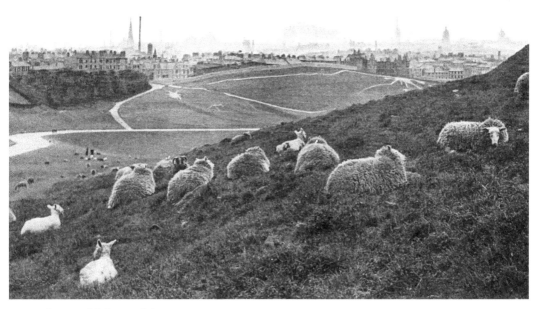

Above and below: Salisbury Crags

The pastoral scene of the sheep contrasts with the array of chimneys in the town. Edinburgh was known as Auld Reekie (smoky) and although the fug was cleaned up in the twentieth century, sheep still grazed in Holyrood Park until 1977.

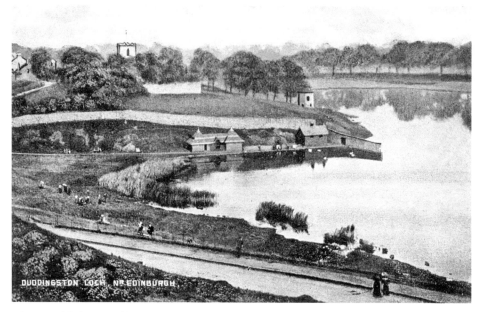

Above and below: Duddingston Loch

The first ice-skating club in the world was founded here in 1724 and the fashion was epitomised by Sir Henry Raeburn's painting of the Skating Minister, the Revd Walker, who was a member of the club. Aspiring members were required to pass a test consisting of completing a circle on each foot, then jumping over one, then two and finally three hats perched on top of each other. In 1761, the Curling Club was started, which quickly became a society in 1795 – the distinctive octagonal building was their curling house. Remarkably, a proposal to drain the loch was put forward but, fortunately, the town's water supply was piped from elsewhere.

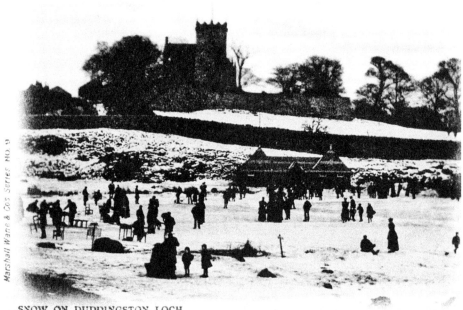

SNOW ON DUDDINGSTON LOCH

Above and below: North Bridge

Once life had settled down after the 1745 Jacobite Rebellion, Edinburgh turned its mind to the matter of unsustainable overcrowding. Lord Provost George Drummond had been making a case for some time about access to the airy space to the north across Nor' Loch valley. Then in 1752, a paper was published entitled 'Proposals for carrying out certain Public Works in the City of Edinburgh' which was the turning point for the town's expansion. Suggestions included drainage of the Nor' Loch, replacement of decrepit housing on the High Street with civil buildings and erection of a bridge across the eastern end of the valley.

The response was enthusiastic and the foundation stone of William Mylne's three-arched bridge was laid in 1763, although it took ten years to complete due to structural problems and a partial collapse halfway through construction. Drummond sadly did not see the finished structure as he died in 1772. The bridge was not replaced until the current one was built in 1896.

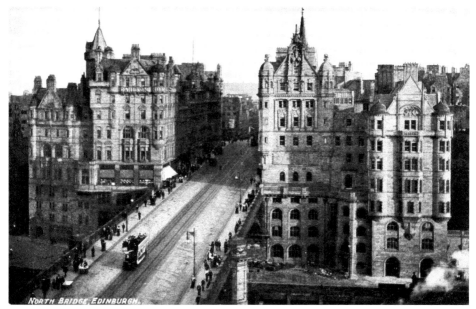

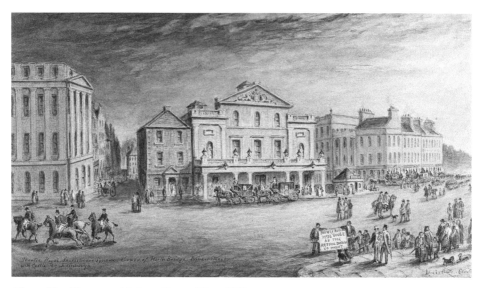

Above: Play House *and below*: General Post Office

Across the North Bridge on the right-hand side, before Waterloo Place and Regent Bridge was built, there was a group of public buildings below Calton Hill, including churches, an orphan hospital and the Play House (or Theatre Royal), which was built in 1768. A statue of William Shakespeare adorned the roof apex, thereby overseeing the development of New Town! His plays were regularly performed here and the location named Shakespeare Square after the bard. During the seventeenth century, theatre was frowned upon by the Kirk, resulting in a sterile period for entertainment, so the early life of Theate Royal was a struggle, but the young advocate Walter Scott took a keen interest in the establishment and his adapted novels contributed exciting new material to Scottish culture.

The painting shows the Theatre Royal prior to major alterations in 1830, although thirty years later it was demolished to make way for the General Post Office.

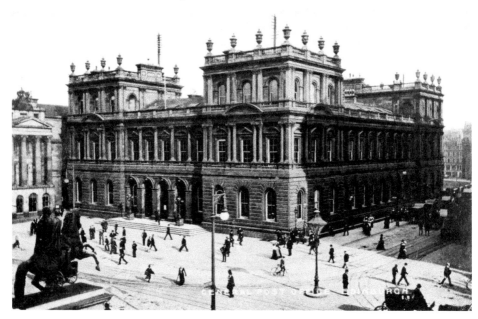

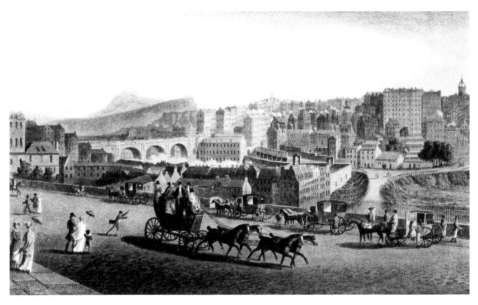

Above and below: Princes Street

Once the decision was taken to expand Edinburgh to the north, a competition was advertised in 1766 for designs. Seven submissions were received by the Architectural Committee, from which James Craig's plan was chosen – albeit he was only 27 years old. Princes Street was the southernmost of three parallel avenues. St Giles Street was to be the original name but the King, George III, took issue with this, due to the reputation of that area in London. He favoured regal nomenclature, hence the present-day names.

A feature of the plans, although not adopted, was a canal in the valley, reminiscent of the Nor' Loch, but the name Canal Street was given to a line of workshops erected there. Later, in 1847, when the Edinburgh, Leith and Newhaven Railway opened, the terminus was called Canal Street Station. The painting shows a goods train entering the tunnel under Princes Street.

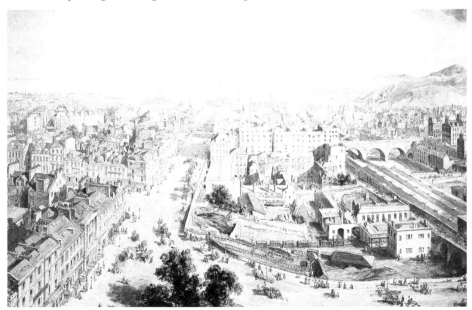

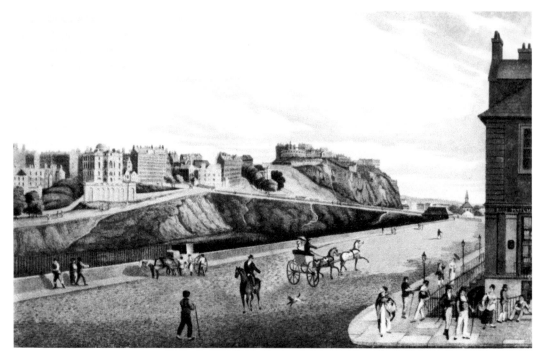

Above and below: The Mound

Enormous quantities of earth were removed from the rural land on which New Town was to be built, and was deposited in the, now-drained, Nor' Loch valley. As it built up, it formed a walkway from the High Street, which ultimately evolved into The Mound, although it was known for years as the Earthen Mound. However, the inspiration may have come from a humbler source: in the early days of construction, it is said that a tartan seller from Lawnmarket had the idea of creating a shortcut across the marshy ground using stepping stones, a route nicknamed Geordie Boyd's mud bridge.

By 1806 the impressive head office of the Bank of Scotland had been built on the eastern flank of The Mound whilst at the foot, the classic building of the Royal Institution (now Royal Scottish Academy) had been opened in 1819, both of which engendered civil pride. In contrast, the motley collection of scruffy structures on the west slope of The Mound were looked upon disapprovingly, especially by the upper classes.

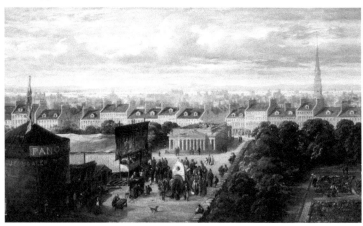

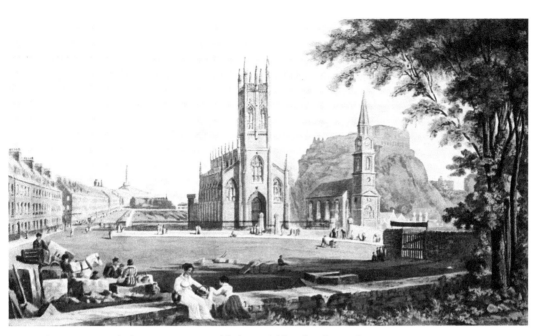

Above: **West End of Princes Street** *and below*: **Kirkbraehead Mansion**

Once Princes Street was completed by 1805, further expansion into the surrounding area was inevitable. Just beyond the west end was the mansion of Kirkbraehead, the kirk in question presumably being historic St Cuthbert's nearby, not the newly erected St John's in the centre of the picture. The estate had originally been part of the lands of Coates – Rutland Square now covers the site of the house which was demolished in 1869 to make way for the Caledonian Railway and associated hotel, rivals of the North British equivalent at the other end of Princes Street.

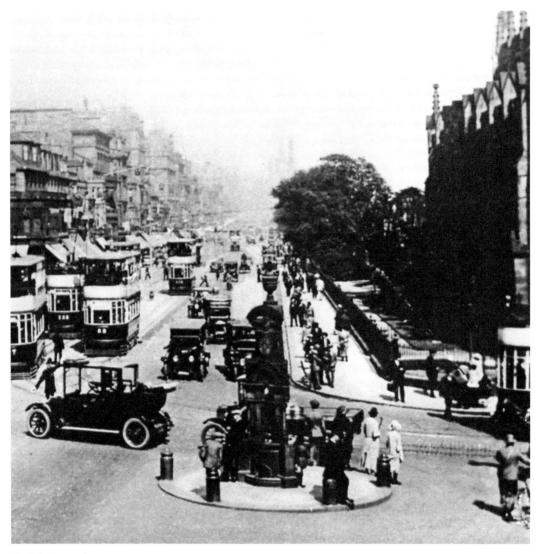

Sinclair Fountain

When horse-drawn transport was still being used, thoughtful benefactor Catherine Sinclair paid for a water fountain to be erected in the centre of the street at the junction of Princes Street and Lothian Road in 1859. Her gift, which was enjoyed by children as well as animals, remained until 1932; the inscription on it read 'Water is not for man alone'. It is easy to see why it became a hazard to motor traffic and the council stored it at Bonnington depot after its removal, but it has recently been given a second life on the cycleway near the Water of Leith.

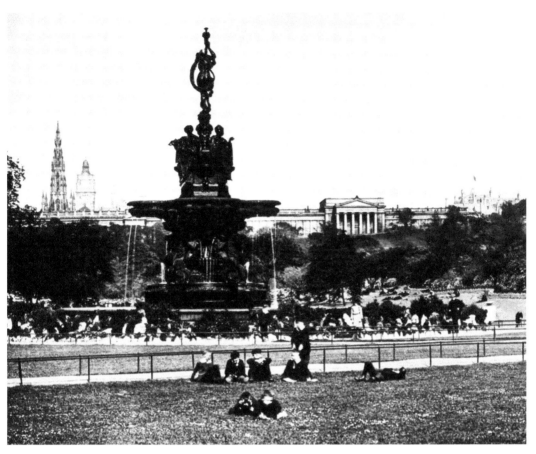

West Princess Street

The residents living between Hope Street and Hanover Street were enthusiastic about the view to the south and keen to prevent any building between their new residences and Castle Rock. The open space in the valley was initially no more than residual boggy land from Nor' Loch, described by Lord Cockburn as 'A fetid and festering marsh, the receptacle for skinned horses, hanged dogs, frogs and worried cats'. A local committee secured lease of the land below Castle Rock, and began an improvement scheme. A walkway was laid along the southern edge, with trees and shrubs being introduced and the whole area surrounded by railings, thus making it a private garden. However, the public were allowed in at times but only after paying a fee. The French cast-iron Ross Fountain was exhibited at the 1862 International Exhibition in London and purchased by Daniel Ross who gifted it to the city.

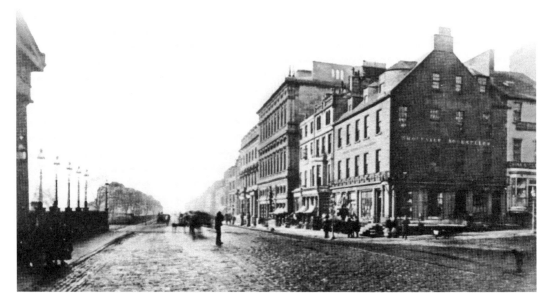

Above and below: **Illumination of Princes Street**

Oil lamps began to be replaced by gas lights in 1819 supplied by the recently established Edinburgh Gas Light Company in Canongate. The first eighteen were erected on North Bridge. The wall-mounted oil lamps in Old Town were converted but in New Town, new lamps standards were erected or attached to metal railings, which were fashionable for enclosing public buildings at that time. By the end of the century, electricity had arrived and in 1881, Princes Street, along with Waverley Bridge and North Bridge, were chosen for trial installations. When the gas lights were removed from the Royal Scottish Academy, they were also set free from its railings.

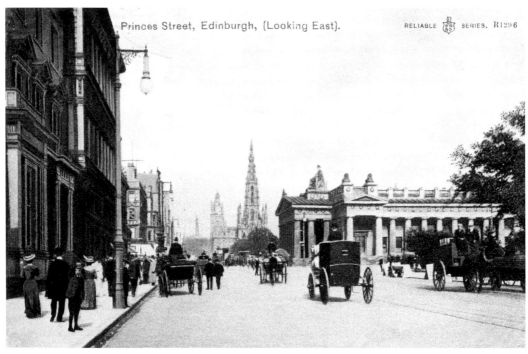

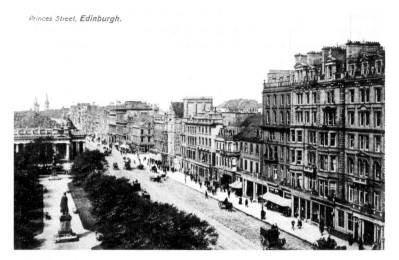

Commerce of Princes Street

When the New Town first developed, the properties on Princes Street were purely residential and provisions continued to be bought from the markets and shops in Old Town or the fruit and vegetable market below North Bridge. The 1819 map drawn by Robert and James Kirkwood shows a track named 'New road to markets' cutting diagonally across the land that became East Princes Street Gardens. It soon became apparent that the ground-floor frontages were suitable for small shops and by 1830, the emphasis was moving from residential to commercial, initially on a small scale and confined to booksellers, clothiers and jewellers. Then larger businesses such as hotels and insurance companies began to appear, altering and expanding premises, such that the roofscape of Princes Street lost its original uniformity.

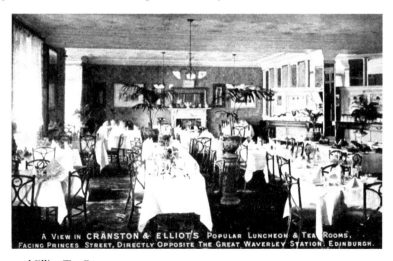

A VIEW IN CRANSTON & ELLIOT'S POPULAR LUNCHEON & TEA ROOMS, FACING PRINCES STREET, DIRECTLY OPPOSITE THE GREAT WAVERLEY STATION, EDINBURGH.

Cranston and Elliot Tea Room

Brigadier General Sir Robert Cranston had a distinguished military career and was Lord Provost of Edinburgh between 1903 and 1906, after which he started a drapery business. The shop was on North Bridge but that site was bought by North British Railways in order to build their hotel. Cranston and Elliot moved to Nos 32–38 Princes Street, previously Rentons Drapery, which had been destroyed by fire. The store sold fashionable silks, costumes and lingerie but above all was famous for the second-floor tea rooms which commanded a wonderful view across to Old Town.

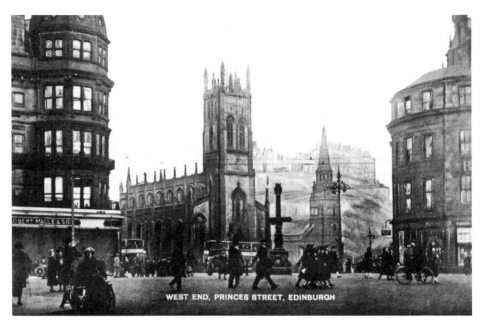

WEST END, PRINCES STREET, EDINBURGH

Maule's Department Store

Established in 1893, it was notable for having the first electric lifts in the city. Their catchy advertising slogan was 'Meet me at Maules'. After Robert Maule died it was taken over by Binns and Sons in 1931 and subsequently by House of Fraser.

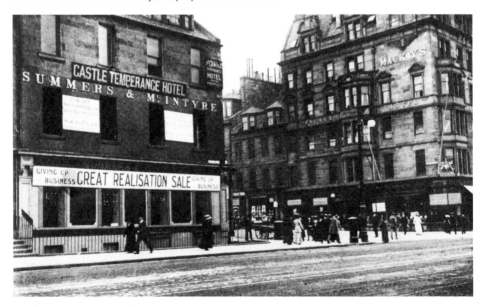

Castle Temperance Hotel

The temperance movement was at its height in the nineteenth and early twentieth centuries when alcohol-free establishments were common. The social movement, rooted in Christianity, believed that drink was the root of all evil and promoted abstinence from alcohol, enabling people to lead longer, healthier and happier lives. (No change there!) Mackays Palace Hotel on the opposite corner of Castle Street was also a temperance establishment.

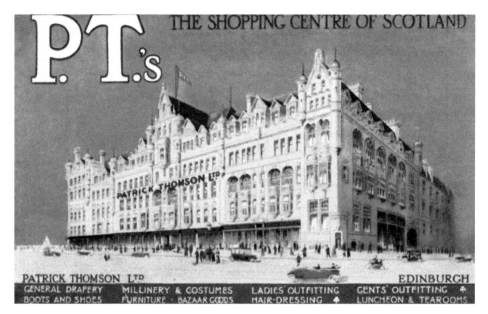

Patrick Thomson Ltd

This large store started life as a small haberdashery shop called Thomson & Allson on South Bridge before moving across the road to larger premises on North Bridge in 1906. The business flourished and, at its height, the stores contained sixty departments. It was affectionately known as PT's and locals were not amused when it was taken over in 1952 by House of Fraser and renamed Arnotts. Whether the change of name had any bearing on it will never be known but twelve years later the store closed.

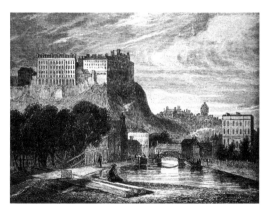

Port Hopetoun

Plans for the Union Canal were approved in 1817 and it was completed five years later. The purpose was to connect Edinburgh with the Forth and Clyde canal near Falkirk, 30 miles away, creating a route between the city and Glasgow to transport both passengers and goods, thus offering a less expensive alternative to the port of Leith. Port Hopetoun was the first canal basin to be dug and where an enormous warehouse was built to store the cargoes, mostly coal, wood, building materials and grain. Horse manure was also carried for delivery from Edinburgh to the rural areas on route for fertiliser. The heyday for passenger traffic was in the mid-1830s when 200,000 people travelled by barge to Glasgow despite the passage taking seven hours to Falkirk and a further six for the onward journey.

Above and below: Usher Hall

Edinburgh benefited from the generosity of some successful businessmen in the Victorian era. The McEwan Hall opened in 1897 thanks to £115,000 given by William McEwan (who owned Fountain Brewery), for the university graduation building. Possibly in the spirit of philanthropic competitiveness, fellow brewer Andrew Usher (North British Distillery Company) offered £100,000 in 1896 to provide the city with a venue for musical entertainment. He stipulated that it should be built within his lifetime in order that he could enjoy concerts there himself. However, the debates over suitable locations dragged on for fourteen years, and Mr Usher died before the site had been picked, let alone a foundation stone laid. Building eventually started in 1911.

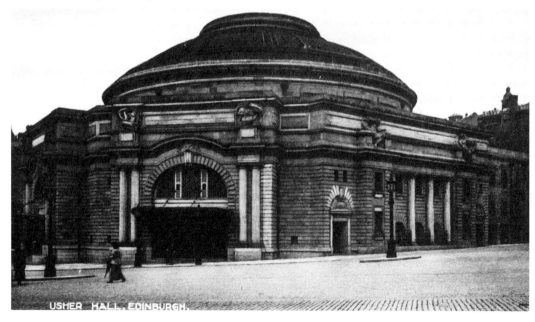

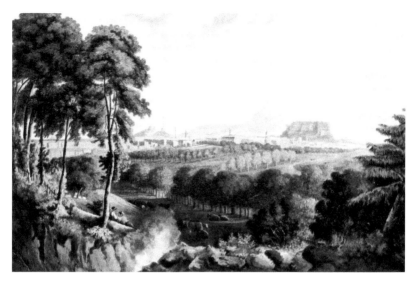

Craigleith Quarry

Craigleith Quarry was the source of 350 million-year-old sandstone used for the buildings of the New Town. This durable stone had been quarried at Craigleith as early as 1619 when James VI ordered it to be used at the castle, then later used for well-known civic buildings including the Tron Kirk, Register House, City Chambers, the City Observatory and University's Old College. However, it was notoriously difficult to quarry and workers frequently died quite young due to injury or dust inhalation. Craigleith Quarry became depleted by the twentieth century and closed in 1942, after which the cavity was filled with the city's refuse until 1985 when Sainsbury's bought the site and opened a store there in 1993.

Moray Place

The north-west boundary of New Town was a 13-acre estate owned by the Earl of Moray and consisted of woodland and open country that spread down the slopes of the Water of Leith. The earl quickly saw the potential of his land and undertook a development of grand, exclusive Georgian terraced houses (designed by James Gillespie Graham) laid out in crescents, thereby breaking the mould of James Craig's linear plan. Moray Place and Ainslie Place were the centrepieces and to this day are considered prestigious addresses.

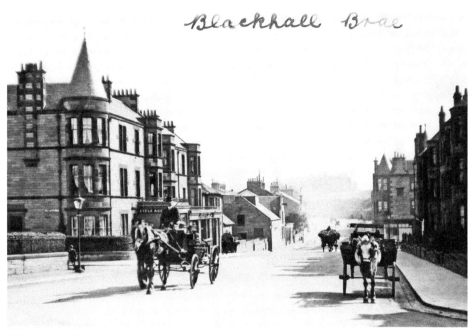

Above and below: Blackhall

This was a rural area until the late 1800s, apart from quarrymens' cottages for the workers at nearby Craigleith Quarry, the sixteenth-century Craigcrook Castle and the mansion house at Ravelston. Development began in earnest after the arrival of the railway; the Caledonian Railway North Leith line from Haymarket to Granton and Leith (with a later branch line to Barnton) passed underneath Queensferry Road but the station itself was perched over the railway line on the south side of the road. It closed to passengers in 1951 and to goods in 1960. The old trackbed has been put to good use as a cycle path.

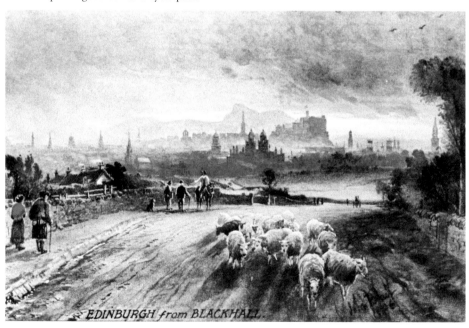

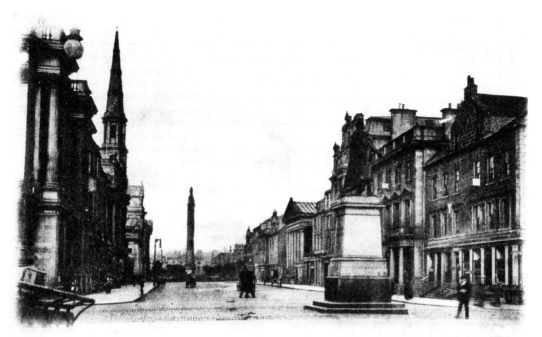

George Street, Edinburgh.

Above: George Street *and below*: Physicians Hall

James Craig's New Town plan centred around three parallel streets, the principal one being George Street in the middle, which was the widest and of highest elevation, which he hoped would attract the wealthiest buyers. Like Princes Street, commerce began to replace residential use in the Victorian era and the location was particularly favoured by banking. Craig also hoped to design the first public building of the New Town with the erection of Physicians Hall at the end of North Bridge but this site had been earmarked for Register House. It was built instead on the south side of George Street, opening in 1781. Unfortunately, it did not live up to the expectations of either the occupants or James Craig as it was cold and not spacious enough and was demolished in 1835. The Commercial Bank of Scotland built their headquarters on the site in 1847 and it is now a prestigious restaurant called The Dome.

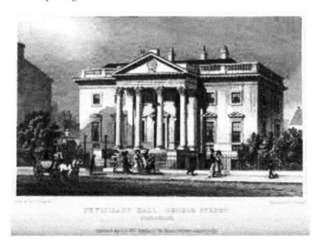

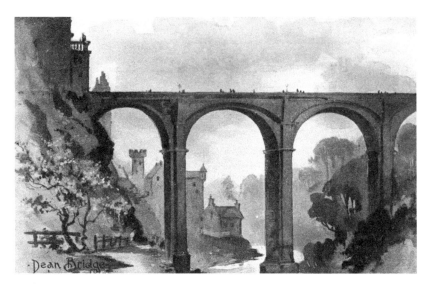

Dean Bridge

Following the development of Moray estate, the natural direction for further expansion was to the north-west, on the other side of the Water of Leith valley. The Dean estate had been purchased by John Learmonth, who sought to emulate the success of the Earl of Moray and considered it was in his interest to pay for a bridge to span the valley. The Dean Bridge, completed in 1833, was the final structure designed by Thomas Telfer. During construction, a builder by the name of Gibb reputedly charged locals a fee to step onto the 100-foot-high structure to admire the view.

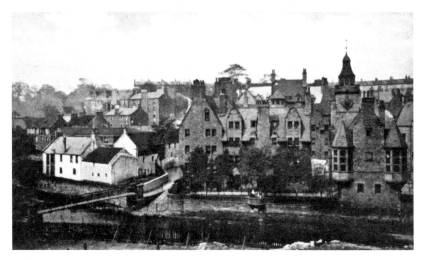

Dean Village

This small independent community, nestling deep below the slopes of the Water of Leith valley, had existed since the twelfth century. Travellers heading west from Edinburgh needed to pass through here, first negotiating the steep, winding, narrow road down to the river before crossing a small stone bridge. The supply of water-power drove the wheels of grain mills, which numbered eleven at one time. In the early 1800s, as the New Town developed, other industries such as tanning and weaving started up, but once the Dean Bridge opened, traffic bypassed the village. Added to this was the competition from larger, more modern flour mills in Leith resulting in a slow decline over the next century, and by the 1960s the village was in an impoverished state.

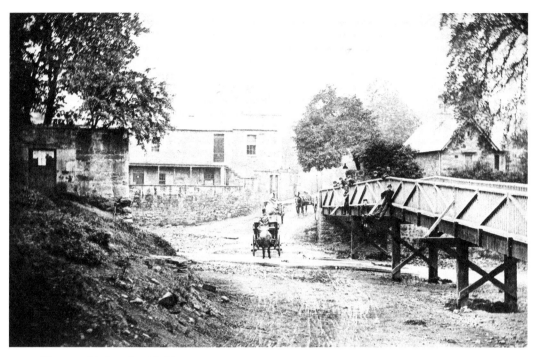

***Above and below*: Stockbridge**

Until the nineteenth century, Stockbridge was a community of farms, mills and tanneries clustered around the Water of Leith. The approach from Edinburgh was steep and led to a ford, beside which was a narrow wooden footbridge, both of which were difficult to negotiate for horses pulling heavy cartloads or when the river was in spate. The wooden structure was replaced by an iron Falshaw road bridge in 1877.

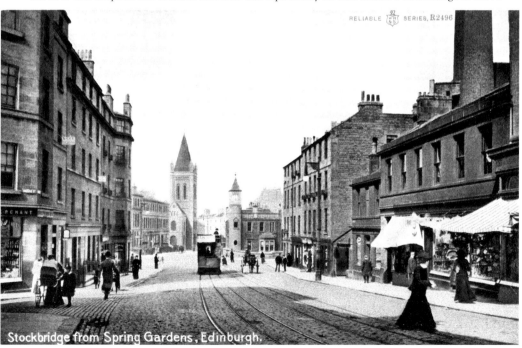

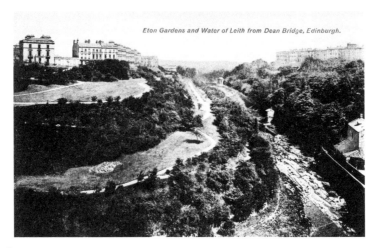

Eton Gardens and Water of Leith from Dean Bridge, Edinburgh.

Eton Gardens

Edinburgh's expansion moved on relentlessly, covering estates and ground that was previously countryside, joining up outlying villages like Canonmills and Stockbridge. To the north of the New Town Eton Terrace had been finished by 1855, built at the top of the steep slopes of the Water of Leith. Below the houses was a grassy area used at that time for grazing sheep. In 1860 residents decided to plant this with trees and shrubs, not only for aesthetic reasons but to prevent further building development and to reduce the risk of landslips. Dean Gardens has matured into a tranquil sylvan retreat close to the heart of the city.

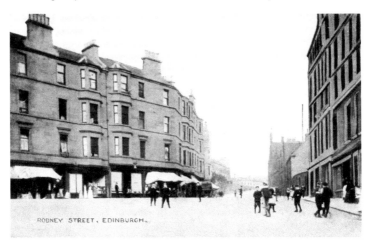

RODNEY STREET, EDINBURGH.

Rodney Street

This thoroughfare links Canonmills to the Bellvue and Clarendon developments. Rodney Street adjoins the western edge of New Town where Canonmills railway station (later named Scotland Street) was built in 1842. In 1847, by a remarkable feat of engineering, a tunnel was hewn through the rock below Princes Street to join the railway to Canal Street station (now Waverley). The Edinburgh, Leith and Newhaven line used horse-drawn wagons to transport goods from the centre of the city to Scotland Street then on to Trinity. The line was then extended to Granton to connect with the ferry to Burntisland. The route closed in 1868. The southern end of the tunnel disappeared with the construction of the new Waverley Market. The northern portal is boarded up but visible from George V Park from where, at the other end, a cycleway has been made along the old railway track and passes through the smaller Rodney Street tunnel.

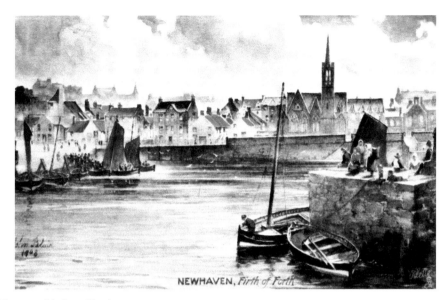

NEWHAVEN, *Firth of Forth*

Above and below: Newhaven

The fishing community of Newhaven, on the Firth of Forth, around 3 miles north of central Edinburgh, was a tightly knit community separate from nearby Leith. James IV aspired to create a Scottish Navy; Leith proved unsuitable for large warships, so in 1504 he ordered a dockyard to be built at Newhaven where the 'Great Michael' ship was built between 1507 and 1511. Tragically, two years later, the Battle of Flodden wiped out not only the King, but vast numbers of men and the naval project was abandoned. James also built the St Mary and St James Chapel in the early 1500s for the shipwrights and mariners working on the vessel but this church was reduced to ruins after the Reformation. Later the site was used as the burial ground for the Society of Free Fisherman, a body founded in 1572 and lasting as late as 1989.

The Gothic Free Church, which remains a landmark, was ministered from 1838 by the philanthropic Dr Fairburn who was concerned about the condition of the boats being used at that time. He suggested a fundraising scheme, doubling the amount with his own money, which resulted in thirty-three new boats being added to the fishing fleet.

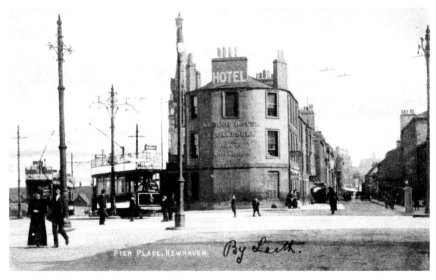

PIER PLACE, NEWHAVEN. *By Leith.*

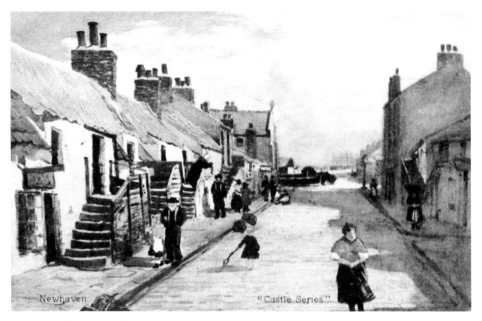

***Above and below*: Newhaven Fishwives**

These feisty women were undoubtedly very strong and tough, albeit dressed in full-skirted outfits, and had a reputation for having sharp tongues. Their myriad practical skills were passed on from generation to generation through intermarrying, as 'outsiders' would have been unable to learn how to mend nets or lines, fillet fish or have the strength to lift heavy creels. The fishwives travelled to Old Town with their full baskets of haddock or oysters and bawled out 'Caller Herring' to make themselves heard above the cacophony in High Street. Once the railways came, they were quick to use this transport to travel further afield to The Borders and East Lothian. Their unique costumes captured the imagination of pioneer photographers David Octavious Hill and Robert Adamson who left a large collection of images.

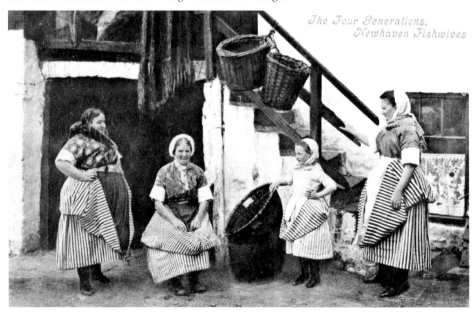

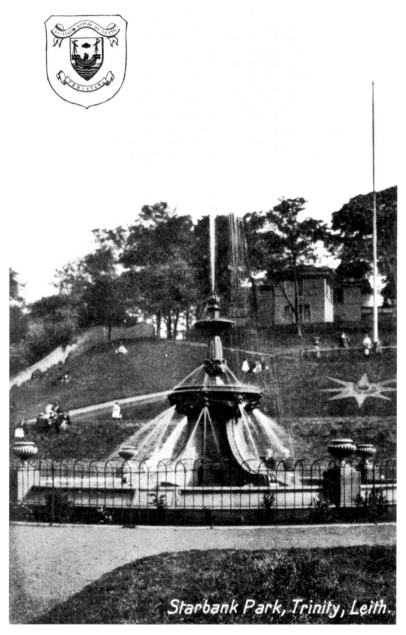

Starbank Park, Trinity, Leith.

Starbank, Trinity

Starbank House was built on the summit of a steep bank overlooking Granton harbour and commanded fine views across the Firth of Forth to Fife. It also had an extensive garden, along the edge of which was a row of cottages. The occupant was Revd Walter Goalen, founder and rector of Christ Church on Trinity Road. When the house became vacant in 1889, Leith Parish Council purchased the property and land to create a public park. At this time Thomas Devlin, originally a fish merchant in Newhaven, had established a successful trawler business in Granton and offered to pay for a water fountain to be erected for his local community. The Devlin Fountain was a popular feature but sadly fell victim to vandalism.

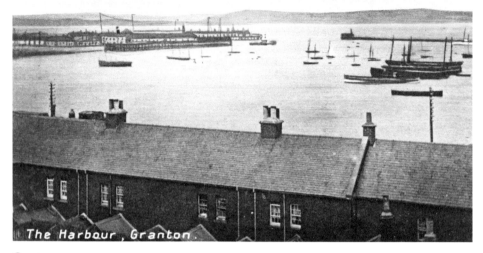

The Harbour, Granton.

Granton

In the 1830s, Edinburgh required a new harbour; Leith was sufficiently undeveloped at that time and Newhaven too small, so the more westerly 'virgin' shoreline of the Forth at Granton was chosen. The Duke of Buccleugh, who owned the nearby estate of Caroline Park, was enthusiastic about the idea and underwrote the construction cost. Building of the central pier began in 1837 and the later east and west breakwaters were constructed over the next thirty years. Coal mined from the Midlothian seam was the main export, whilst large quantities of Esparto grass were imported for paper production. The Edinburgh, Leith and Newhaven railway line was extended to Granton in 1847, boosting industry in the vicinity and the novelty of starting the world's first ferry-train in 1850 (the paddle-steamer was called Leviathan) guaranteed that Granton was a thriving community. The ferry crossing to Fife continued until 1890 when the Forth Bridge was opened and although car and passenger ferries survived until the 1960s, the industrial revolution was over for Granton.

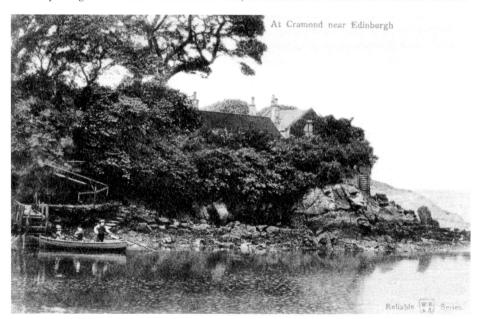

At Cramond near Edinburgh

Reliable W.R. Series.

68

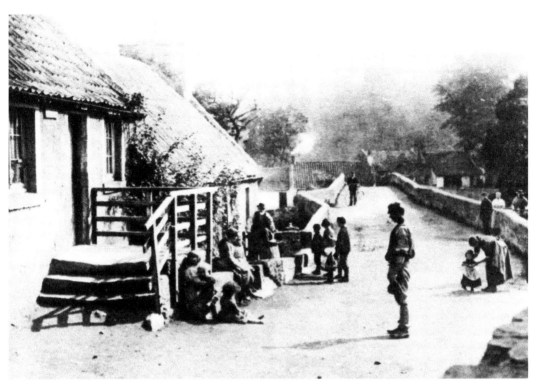

Above and opposite below: Cramond

This attractive village at the mouth of the River Almond was occupied by the Romans around AD 142 when a garrison was built to connect to the Antonine Wall further up the river. Evidence of their presence was recently established when the ferryman discovered a Roman stone lion buried beneath the landing stage. It is now exhibited in the Museum of Scotland.

In the seventeenth and eighteenth centuries, small industries, particularly grain mills, were established along the river but these declined during the 1800s.

The ferry from Cramond to the Dalmeny estate began in the mid-nineteenth century and the short journey in the wooden boat was very popular, and the ferryboat men, who lived in the cottage above the jetty, known as local characters. The ferry stopped at the outbreak of foot and mouth disease in 2000 and was never restarted. However, there is currently a campaign to reinstate the service.

Without the ferry boat, the next crossing of the River Almond is around a mile upstream. This bridge dates back to the early sixteenth century but has undergone many repairs and is only used by pedestrians or horses.

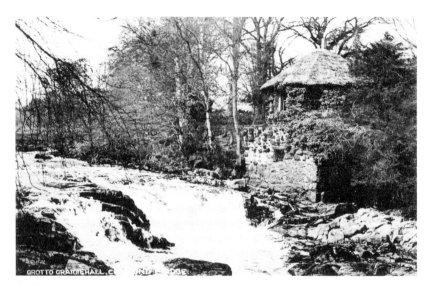

Craigiehall Grotto

Craigiehall was built for the 2nd Earl of Annandale in 1699, replacing a fourteenth-century tower house. The property and estate were then inherited by his nephew, 1st Earl of Hopetoun, in 1741. The new owner was keen to improve the policies and toured Europe with the young architect Robert Adam in the 1750s looking for inspiration. On his return, he cleared away the formal gardens and instead, planted avenues of trees, as well as erecting a variety of garden buildings. A rustic single-arch bridge was constructed across the River Almond, just upstream from which a Roman-style stone bathhouse and grotto, topped by a conical thatched roof, was built on the riverbank. This is now a ruin, but the remains can still be seen.

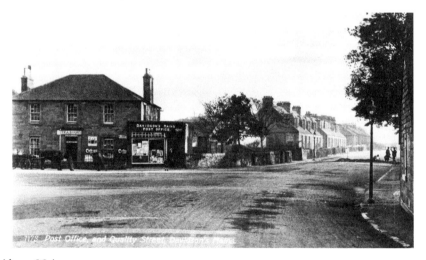

Davidsons Mains

The name comes from Captain William Davidson, a merchant who had made his fortune in Rotterdam and owned the nearby Muirhouse estate. The rural parish, originally known as Muttonholes, did not change significantly until after the Second World War, although the opening of the branch line railway between Craigleith and Barnton in 1894 heralded the changes that were to come. There is a well at the entrance to the park in the grounds of Lauriston Castle, from which water was drawn until 1932 when pipes were laid from a spring on Corstorphine Hill.

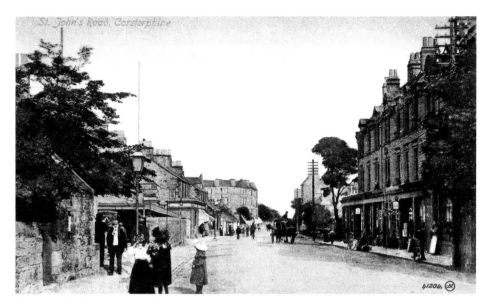

Above and below: Corstorphine

To the west of Edinburgh, Gogar Loch and Corstorphine Loch, both of which were remnants of the last Ice Age, were divided by a strip of land on which the settlement of Corstorphine began; it was first mentioned in the Ragman Rolls in 1296. In the fourteenth century a castle was built for the Forrester family and although it no longer exists, a sixteenth-century beehive doocot remains in the original castle grounds and is a feature easily visible in Dovecote Road.

In the 1700s, daily horse-drawn coaches brought people from Edinburgh to a mineral well – the Physic Well – renown for its restorative powers. A later speciality for which the village became famous was Corstorphine Cream, a cultured cream cheese.

The main road to Glasgow passed through Corstorphine, so, historically, its main street, St Johns Road, has always been full of traffic. The area escaped major industry but by the twentieth century began to be subsumed into Edinburgh's expansion.

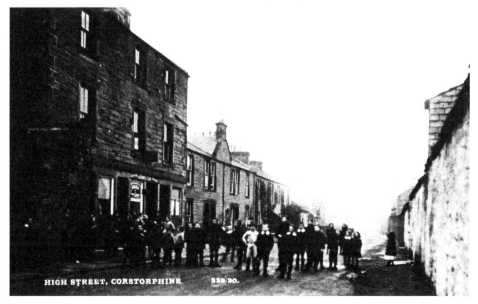

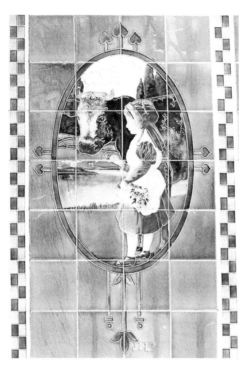

Above and opposite: Buttercup Dairy Company

Clermiston was the centre of an unusual business venture in the early twentieth century. Andrew Ewing, an apprentice grocer in Dundee, having been promoted to manager, realised he wished to run his own shop. He settled on Leith for his head office partly to be near the port, as he was importing eggs at that time from Poland and Denmark. This is when the Buttercup Dairy Company was born and soon Andrew established an identity for his 'brand' by decorating every shop doorway with the distinctive and attractive green tiles depicting a little girl holding a buttercup under the neck of a cow – 'Do you like butter?' It was clever marketing for the early twentieth century. The business went from strength to strength and larger premises were procured in Easter Road. The 2-acre site included a poultry farm of 3,000 hens which was open for the public to 'inspect' but had to entered via the shop!

In 1922 Andrew Ewing purchased the 86 acres of Clermiston Mains, believing that he could produce sufficient home-grown eggs to supply his chain of shops; by 1928, 200,000 laying birds were being accommodated there and the combination of roads, huts, hatcheries and offices earned the farm the nickname 'Hen City'. At its height, Buttercup Poultry Farm employed 100 staff and supplied 250 shops.

There was another side to this successful entrepreneur however, which, to our twenty-first-century sensibilities, may seem rare. Andrew Ewing was a devout Baptist who believed that one's riches should be shared with others less fortunate. He ran the company in a disciplined manner but placed huge importance on the care and welfare of both staff and hens, as well as donating all the eggs laid on Sundays to charity. His generous charitable donations ultimately created financial problems for Buttercup Dairy, compounded by a major fire. By the 1950s, the business was in debt and many Buttercup shops had closed, so when Edinburgh City Council offered to buy some land adjacent to Clermiston Mains for much-needed housing, he agreed. This money offered a short-term reprieve and the poultry farm still operated but on a smaller scale. When Andrew Ewing died in 1956, it was apparent that the business was worthless and he had achieved his wish to die a poor man. In 2014, Edinburgh Council opened a new area of parkland on the site. It is named Buttercup Farm Park in recognition of its predecessor.

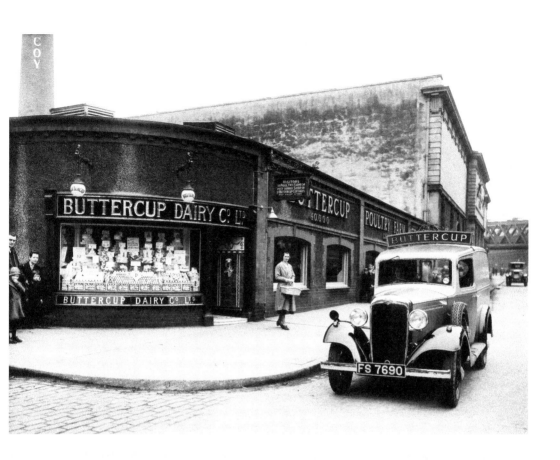

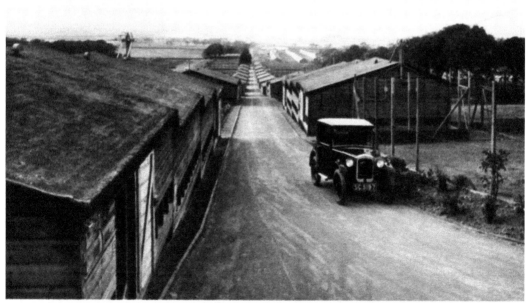

Buttercup Poultry Farm in the late 1920s: the view down Road 1

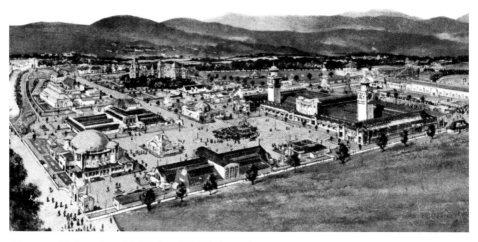

Above and below: **Scottish National Exhibition, 1908**

The 42-acre grounds of Saughton House had been purchased by the Edinburgh Corporation in 1900 and were spacious enough to hold this major event, which lasted six months. The fashion for these expositions began during the Industrial Revolution and the first was the Great Exhibition of 1851, held in Hyde Park. This was an era when Britain was proud of its contribution to industry, art and trade and wished to 'show-off' the achievements to the rest of the world.

Three and a half million visitors enjoyed the diverse entertainment at Saughton, which ranged from fairgrounds to an authentic Senegalese village, complete with bemused natives. The centrepiece was the Palace of Industry built in Arabian architectural style. When it was dismantled, some of the structures were rebuilt at Seafield to create the Marine Gardens, which were closed at the outbreak of the First World War.

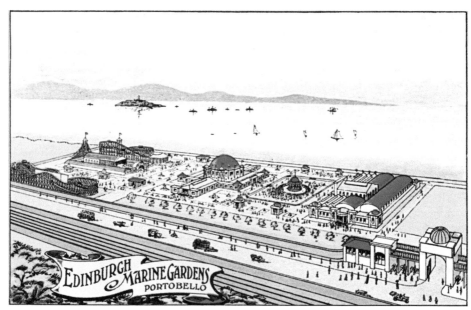

ADMINISTRATIVE BLOCK, ROYAL VICTORIA HOSPITAL, EDINBURGH.

Royal Victoria Hospital

In 1894, Craigleith House was rented by tuberculosis specialist Dr Robert William Philip, as a sanatorium to augment his clinic in Bank Street. The Victoria Dispensary for Consumption and Diseases of the Chest practised what became known as 'the Edinburgh Scheme' – prevention, detection and treatment of tuberculosis. The isolated location of the house and grounds fulfilled the requirements for TB patients prior to the advent of antibiotics. It was not until 1955, when drug therapy was successfully curing patients, that the hospital changed to long-term care for the elderly. In 1960, Craigleith House itself was demolished to build more suitable accommodation and it became the principal geriatric hospital for north Edinburgh until 2012.

Braidburn Dairy

Hermitage House, in woodland between Braid Hills and Blackford Hill, was built for Charles Gordon of Cluny in 1785. At that time this area was quiet rural farmland. Morningside, just down the hill, consisted of a handful of thatched cottages, a smithy and an inn and didn't develop until the mid to late 1800s. Braidburn Dairy, also known as Duff's Dairy, was one of several in the district but was demolished in 1937 and replaced by a lodge house built from masonry from the demolished toll house at Morningside. Hermitage House was given to the city in 1937 by owner John McDougal and is used as a visitor centre for the nature reserve in the hermitage of Braid.

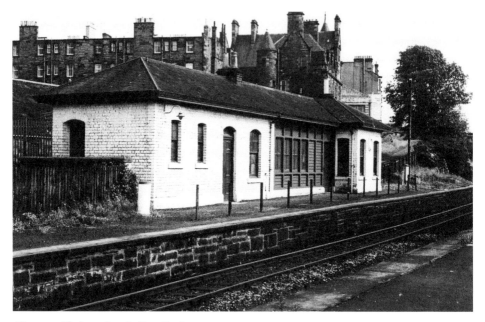

Above and below: Gorgie East Station

In 1884 the Edinburgh Suburban and Southside Junction Railway was opened for passengers and freight around the southern suburbs of the city. Gorgie station (changed to Gorgie East in 1952) was essential for the nearby McVitie & Price Biscuit factory and North British Distillery to transport their products. The station closed to passengers in 1962 and the station buildings and two platforms have been completely cleared away.

In the last decade campaigners have attempted to persuade the Scottish government to consider reopening the line but the proposals have been turned down on economic grounds.

Haymarket was the next station on the line and up to 1963, steam engines were seen, heard and smelt moving in and out of the large iron engine-shed. They were replaced by diesel, but the shed survived; it was dismantled and rebuilt at the Bo'ness and Kinneil Preservation Railway on the Firth of Forth.

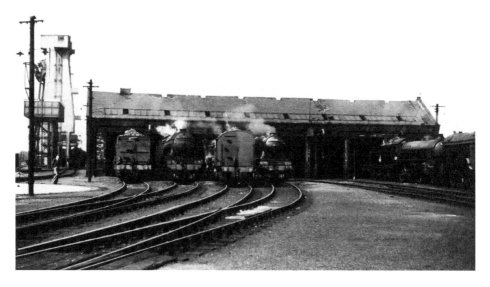

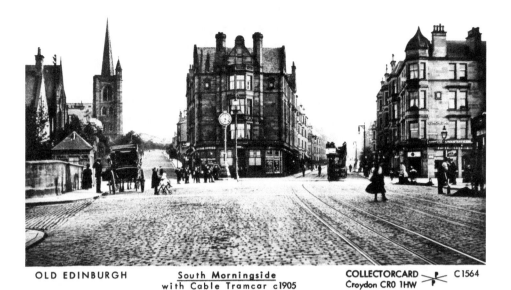

OLD EDINBURGH **South Morningside**
with Cable Tramcar c1905 COLLECTORCARD C1564
Croydon CR0 1HW

Above and below: Morningside Road Station

The suburb of Morningside was also served by the Suburban and Southside Junction Railway. The station, opened in 1884, was entered through a gate on the west side of the road and the station buildings were adorned with ornate canopies, typical of North British Railways style. The clock in the centre of the photograph was for the benefit of rail travellers but was subsequently moved to the pavement when the road junction was realigned to cope with the increased volume of motor traffic. The line was closed to passengers in 1962 but continues to be used for freight. The station buildings were converted to shops but a vestige of the era is the iron footbridge crossing the line between Balcarres Street and Maxwell Street.

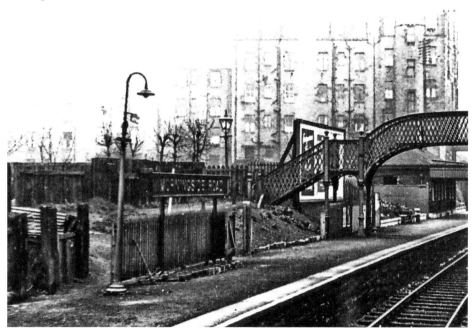

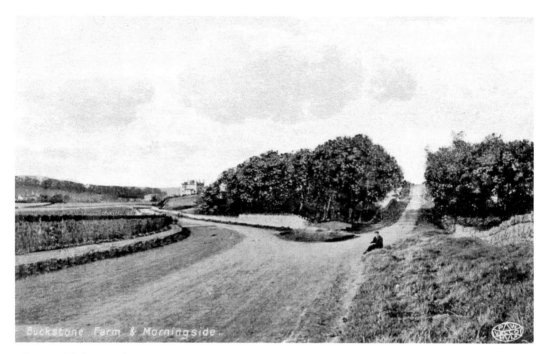

Above and below: **Buckstone Farm**

The photograph above, looking north, shows the route from Biggar to Edinburgh, used for centuries to bring produce from the countryside to the town's markets. Braid Road on the right was a narrow lane passing Mortonhall Golf Clubhouse (founded 1892) and Buckstone Farm. At this time, the now busy crossroads at Fairmilehead consisted of two cottages, a wooden signpost and a milestone. A large standing stone – the Caiy Stane, thought to be Neolithic – stood nearby and now resides in a niche on Caiystane View. The art-deco Hillburn Roadhouse was built in 1937 on the site of Bow Bridge, south of the crossroads but was demolished in the early twenty-first century.

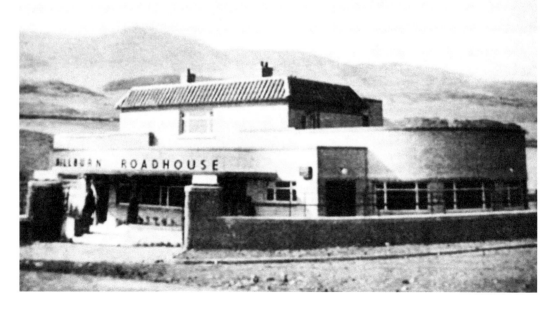

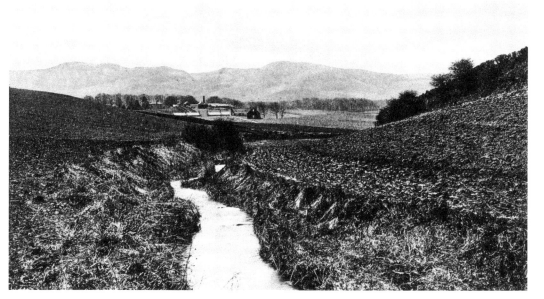

Above and below: **Braid Burn**

The Braid Burn flows from springs at Comiston, the area from which piped water was first taken into Old Town in Edinburgh. In 1672, five well-heads were installed at different locations in the High Street to provide fresh, clean water to the citizens. When they became redundant in 1945, the authorities placed marker stones at the head of each spring to commemorate the contribution made to the town's history. Each spring head is named: Peewit, Peewit 2, Sandglass, Hare, Moubray, Fox 2 and Fox 3. This park was created from the fields of Greenbank Farm in 1933 as a public amenity for the ever-growing suburb on this south side of town. Building in Greenbank Drive began in 1910; the attractive stone houses replaced properties such as this thatched cottage, the last one standing in Greenbank Drive.

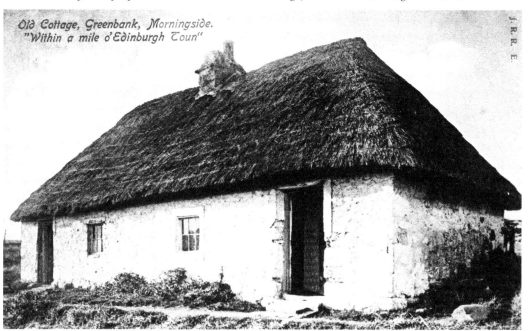

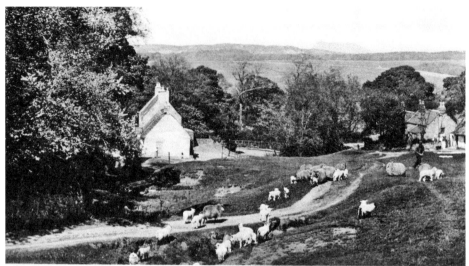

SPRING TIME AT SWANSTON — JAMES PATRICK

"A stilly hamlet home that vies
With any earthly paradise."—R.L.S.

Above and below: Swanston

The water supply from Comiston springs eventually became insufficient for the town's growing population and in 1758 Parliament passed an Act for the flow to be augmented by water from Swanston. A cottage was built as a meeting place for the water baillies and this was enlarged to a sizeable house in 1835, best known as the summer retreat of Robert Louis Stevenson and his family from 1867 to 1880.

The hamlet nestled below the slopes of Caerketton in the Pentland Hills and consisted of a farm, thatched cottages for the labourers and a school. It was remote from Edinburgh until urbanisation spread to within half a mile of it during the twentieth century. By the 1960s the old cottages were dilapidated but were restored by Edinburgh Council using grasses from the reed beds in the Tay estuary for the thatched roofs.

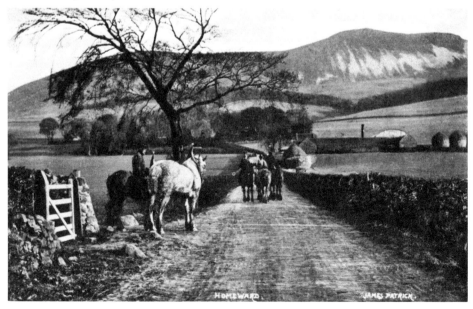

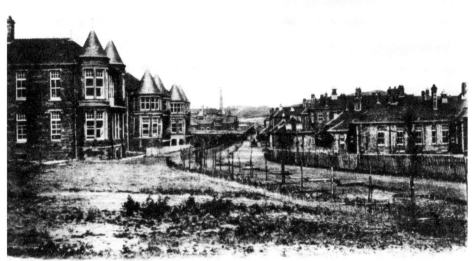

Colinton Mains Hospital, Edinburgh.

RELIABLE 🛡 SERIES.

Above and below: Colinton Mains Hospital

By the end of the nineteenth century there was an urgent need for a new hospital dedicated to infectious diseases as the City Fever Hospital in High School Yards was inadequate to deal with outbreaks of infections like cholera and smallpox.

Colinton Mains Hospital, later renamed City Hospital, was built on an elevated rural site close to where the old Craiglockhart Poorhouse had been opened in 1903. It was designed by architect Robert Moreham who had been instructed to fulfil the criteria of the day, providing parallel pavilions with end balconies, allowing patients a plentiful supply of fresh air, as well as isolation cottages. In 1913, a unit was added for TB sufferers. The City Hospital was closed in 1999 when the buildings were converted into living accommodation.

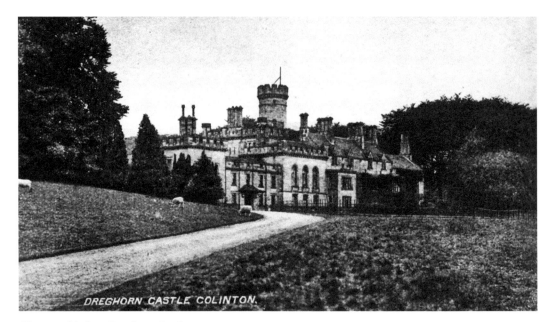

Above and below: Dreghorn Castle

This mansion was built in 1658 for Sir William Murray, Master of Works to Charles II, on land above Colinton village and overlooking the Pentland Hills. Over the next 200 years the estate frequently changed hands but was acquired in 1862 by Robert Andrew Macfie who erected a monument to the Covenanters, using ionic columns he rescued from the old Royal Infirmary when it was demolished in 1884. The house was cleared in 1955; local people believe that the edifice was used for target practice by the neighbouring Dreghorn Barracks which are situated in part of the old castle grounds. The lodge house was demolished in 1970.

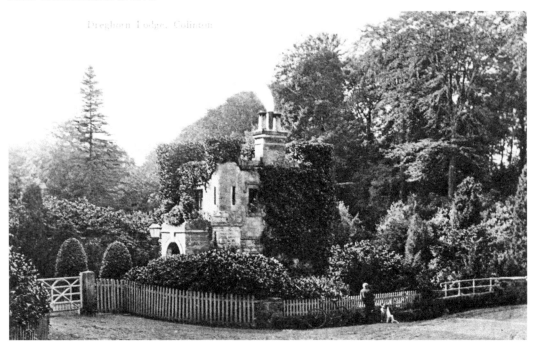

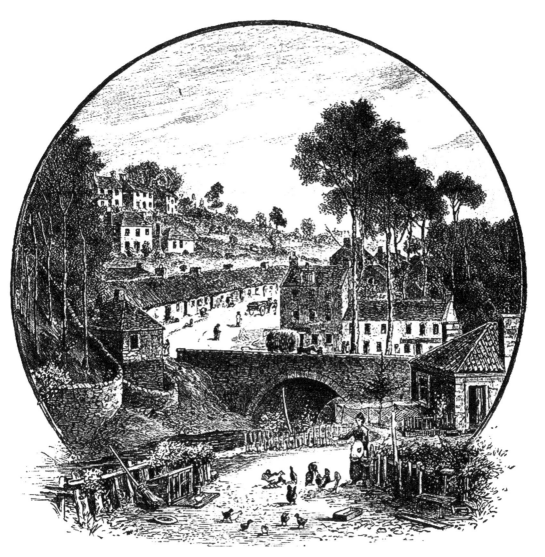

Colinton

The Water of Leith is the only river that flows through Edinburgh. Consequently its course was peppered with mills – seventy-six at the height of the industrial era. Colinton village lies in the steep-sided gorge of the river, and grew up around the mills. Redhall Mill printed the paper for the first banknotes in 1718 and within living memory, the Scott's Porage Oats factory displayed the famous kilted mascot on a hoarding beside the road. In 1874, the Caledonian Railway opened a branch line from Slateford to Balerno with stations at Colinton and Juniper Green, marking a turning point for the rural community as townspeople were attracted to the area. None of the mills exist now and the trackbed of the railway, which closed in 1967, is used as a path and cycleway along the sylvan Colinton Dell.

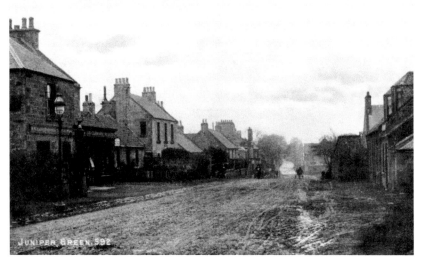

Above and below: Upper Valley of Water of Leith

Juniper Green does not appear on maps until early in the nineteenth century and was really an area of moorland known as Curriemuirend, where hangings were purportedly carried out. It was first noted in 1707 in the records of Colinton Parish Church, at which time there were only a few cottages, but during that century, corn, snuff and paper mills became established. The water flow was variable, being so far upstream, so a series of lades, sluices and weirs were constructed along this stretch of the valley. In the mid-1800s Harperrig, Threipmuir and Harlaw reservoirs were made at the foot of the Pentland Hills as compensation reservoirs, able to store water over the winter and release it in summer.

The railway facilitated accessibility to this western suburb of Edinburgh and in Victorian times, a ribbon of villas was on the northern side of the valley, later followed by development on the south. This branch line left the Edinburgh to Carstairs line at Slateford, then called at Colinton, Juniper Green, Currie, Balerno and on to Ravelrig where it turned round – the so-called Balerno Loop. Eventually, urban spread swallowed up Juniper Green and Currie. The railway remained open for freight until Kinleith Paper Mill shut in 1965.

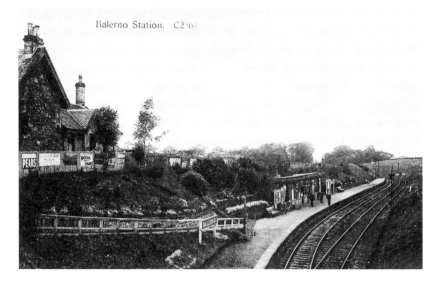

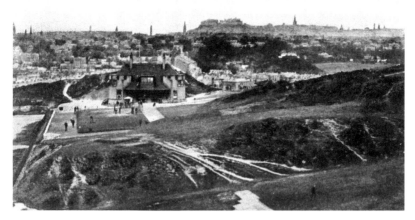

Braid Hills Golf Course

In 1893, Edinburgh Corporation bought the land on Braid Hills and laid out a municipal golf course over the next few years. The elevated position to the south of the city offered unparalleled views to Edinburgh and the new course attracted golfers who had previously played on Bruntsfield Links. On the east side of the course was a small natural body of water which was popular with skaters ... but not with the golfers, so it was drained in the mid-1920s despite a campaign to save it. There was also an isolated building under the name of Winchesters Refreshment Rooms, listed in the 1909–10 Edinburgh Post Office Directory as run by G. C. Elspet Winchester, which provided sustenance, despite not being supplied with water, gas or electricity!

Kingston House

The Gothic edifice of Kingston House was designed by architects Pilkington and Bell in 1860 for wealthy tailor William Christie. He sold the property to the council in 1918 for £13,000. Towards the end of the First World War, they converted it to a hospital to treat soldiers suffering from shellshock. Craiglockhart Hospital was the only other facility of this kind but only treated officers, not the lower ranks, and where the condition was called 'neurasthenia'. It was anticipated that the University of Edinburgh would take over the Scottish National Neurasthenics Hospital for further research into the condition but it closed suddenly in 1925 and the premises lay empty for a while. Since then it has been variously a school, hotel, health spa and now luxury flats.

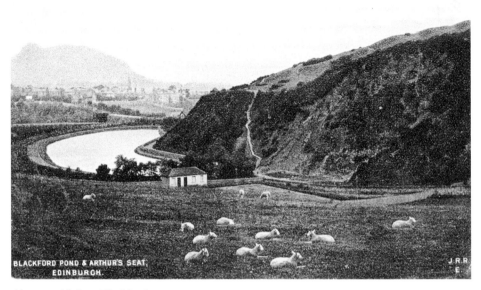

Above and below: Blackford

Blackford Hill, part of Mortonhall estate and owned by Lt. Colonel Henry Trotter, was sold to Edinburgh Corporation in 1884 for £8,000. The hollow below the hill had been scraped out by a glacier during the Ice Age but the man-made pond was created for skating and curling. In 1848, the Merchiston Curling Club was oversubscribed so a break-away group formed the Waverley Curling Club which moved to Blackford.

The valley in which this lies is that of the Jordan Burn and the land belonged to Egypt Farm. These names, together with nearby Canaan, Eden and Goshen, led one author to nickname it 'Edinburgh's Bible Belt'. The reason for the nomenclature is unclear. The pasture where sheep once grazed has been turned over to allotments.

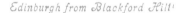

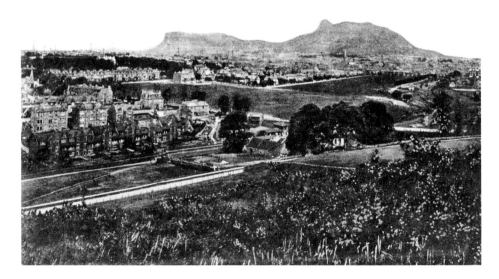

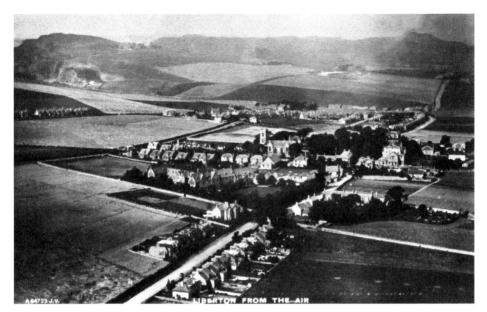

Above and below: Liberton

This aerial photograph was taken when the villages of Liberton were still rural communities distinct from Edinburgh. There were four scattered groups of houses comprising the whole: Kirk Liberton, which is self-explanatory; Liberton Dams, at the foot of the brae; Nether Liberton, between Craigmillar Park and Gilmerton crossroads; and Over Liberton, around The Tower. The prominent features are Liberton Kirk and St Hilda's School for Girls to the right of that, with Lasswade Road cutting through the centre. The long, steep Liberton Brae was made in 1815 using rough materials in order that the cartwheels had traction. In 1910, the shops and houses at Braefoot were built and thereafter the agricultural land gradually filled up with housing estates transforming the area into a suburb of the city.

The lower area of Liberton has altered beyond recognition, although, until very recently, a few boarded-up traditional cottages could be glimpsed poking up from patches of overgrown wasteland. These too have now been replaced by modern housing.

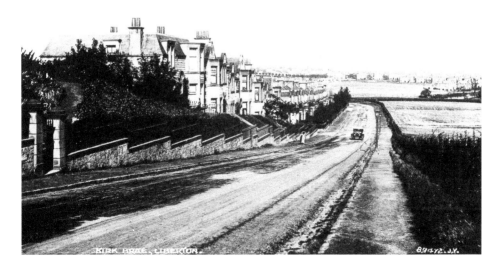

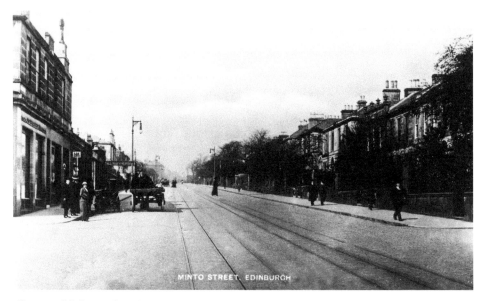

Above and below: Minto Street

A feu plan for Newington was passed by an Act of Parliament in 1794 which included the proposed route south (Minto Street) described as the 'intended new road to London'. In 1803, a large area of land was purchased by eminent surgeon Benjamin Bell, who planned to build Newington House, started in 1805. The same year Bell died, and his son George inherited the estate. He asked the architect, James Gillespie Graham, to draw up plans for properties in the surrounding grounds with explicit instructions to forbid 'any manufactory of soot or blood, breweries, distilleries, tan works, kilns or any manufactory which could be regarded as a nuisance'. Gates with ornate piers were built by the lodge houses at both entrances to the Blacket estate, named after the Bell family home in Dumfriesshire, creating an early-day gated community! Newington House was demolished in 1966. By the 1860s the area had become densely populated and was served by horse-drawn buses in 1850, then horse-drawn trams by 1871.

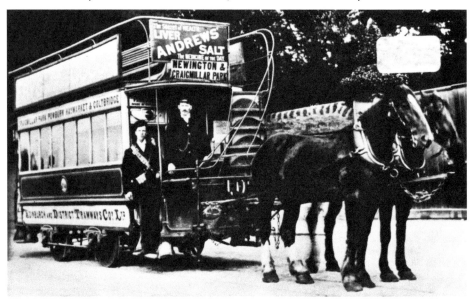

Above and below: The Dick Vet

The history of the Royal Dick School of Veterinary Medicine began in the 1820s when lectures were presented in modest, pokey premises in Clyde Street. William Dick and his father bought the house in 1831 and over the next two years extended it, adding a lecture theatre, stables, dissecting room, museum and small animal hospital. Over the next few decades, adjacent properties were also purchased and converted to other facilities. William Dick died in 1866 but the Clyde Street College continued to operate until 1916 when a purpose-built veterinary college at Summerhall was created. To accommodate the neoclassical building, the row of cottages and United Presbyterian church in the photograph were demolished. The establishment was affectionately known as the Dick Vet. The veterinary school is now located at Easter Bush Campus.

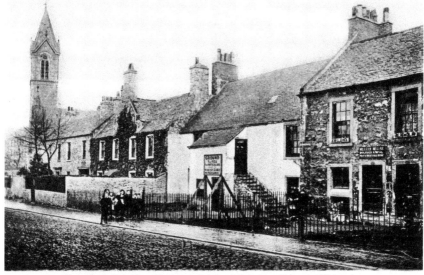

Hope Park Church and Summerhall (site of Veterinary College), Edinburgh.

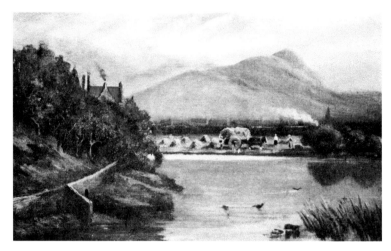

Lochend

The farmland of Restalrig stretched between Arthur's Seat and Leith and was overseen by Lochend Castle. The tower house was owned by the Logan family of Restalrig who, from the fourteenth century, had become the most powerful landowners in Leith but their estate was forfeited by Parliament in 1609 after he was implicated in an attempted abduction of James VI. The castle passed to the Elphinstone family but eventually fell into ruins. In 1820, the remains of the old tower were incorporated into Lochend House. A sixteenth-century beehive doocot has survived the changing fortunes of the house. The residual glacial loch, which is fed by underground springs, ceased to be used to supply drinking water to Leith in the 1920s when the surrounding agricultural land was earmarked by the council for dense social housing.

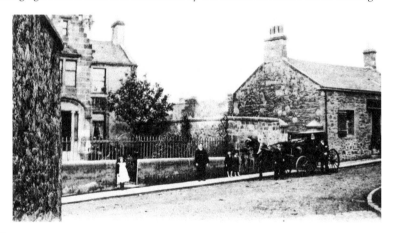

Restalrig

Restalrig House and Lochend House are twentieth-century names given to blocks of flats but both did exist historically. Restalrig House was demolished in 1963 and the land is covered with modern housing and Lochend House has been described earlier. The existence of a church is recorded in the twelfth century but it was extended and rebuilt in 1477 by James III, who created a collegiate establishment known as the Deanery of Restalrig. An unusual hexagonal chapel, St Triduana's Aisle, was also erected, dedicated to a Pictish saint who was believed to have the power to cure eye conditions, bathing pilgrims' eyes with water from the nearby St Margaret's Well. In 1560 the old parish church fell victim to the Reformation and was reduced to rubble, although the lower storey of the chapel did survive and in 1907, restoration was undertaken and a pitched roof added.

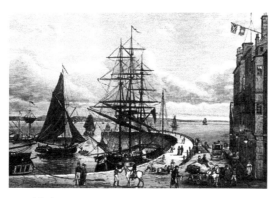

Above: Leith Harbour *and below*: The Shore

King Robert the Bruce handed Leith harbour over to Edinburgh in 1329 as its port and as such, the town owned the revenues, which made for a fractious relationship between the two places for centuries. This situation began to change in 1827 when the Town Council agreed to let Leith elect its own councillors and magistrates and a decade later, an Act of Parliament transferred the dock customs to a new Dock Commission. The burgh was finally incorporated into Edinburgh City in 1920, but not willingly on Leith's side.

In the seventeenth century, the harbour at the estuary of the Water of Leith was not much more than a pier and anchorage but despite this, it was Scotland's main point of entry from the sea. The wharf side was lined with maritime trade buildings, whaling ships were sailing to Newfoundland, monarchs arrived and departed (even escaped), the Scottish Navy was in existence and trading ships regularly sailed to and from Europe and towards the close of this century, ships of the ill-fated Darien Expedition set sail for South America.

The small town was built up around both sides of the river which divided it into North Leith and South Leith, but it was isolated from other communities and fiercely independent.

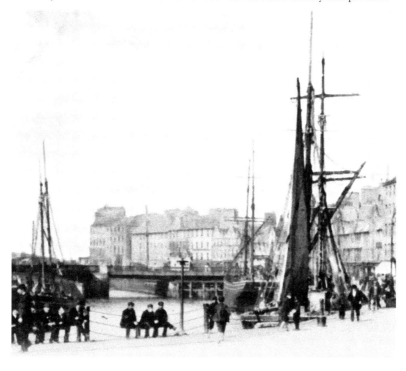

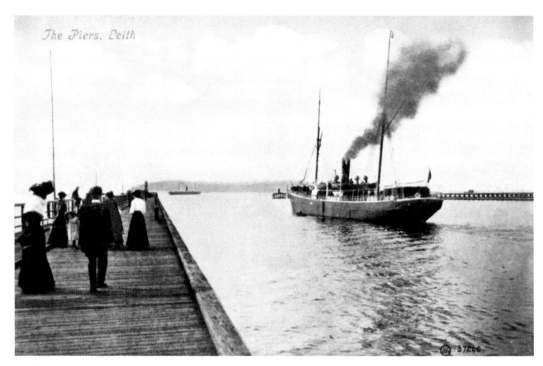

The Piers. Leith

Docks

Medieval ships sailing into Leith found anchorage at the wooden pier along the east side of the estuary of the Water of Leith; the twenty-first-century docks and their hinterland illustrate the development of the port over the centuries and the changing identity of Leith. The first dry dock (traditionally called graving dock) was made in 1771 at Sandport where Customs House now stands, but rapid expansion began when the foundation stone was laid in 1801 for the East Dock, finished in 1806, soon followed by completion of West Dock in 1818. Trade flourished in the Victorian era, resulting in Victoria Dock being built by 1852, then Albert Dock in 1869, Edinburgh Dock in 1881 and Imperial Dock in 1904, each larger than the last. Passenger steamships regularly sailed from the West Pier and industries thrived around the port, transforming the small town into a major commercial port within a century.

In the 1930s, construction work began on the Western harbour whose deep water was enclosed by two huge breakwaters. However, the fortunes of Leith were to change as the twentieth century progressed. After the Second World War, the town went into a slump, then railway services were withdrawn, shipbuilding finished and commercial shipping declined as the port was unable to handle the large modern container ships and the area became synonymous with crime and prostitution.

An optimistic future lay over the horizon however. Post-industrial Leith has metamorphosed into a vibrant, colourful and desirable place in which to live and work. City of Edinburgh Council began a development scheme around the waterfront in the 1990s, converting warehouses into business premises and building blocks of contemporary flats. At the same time, the Shore area became known for high-class restaurants, Royal Yatch Britannia came to live behind Ocean Terminal, the Scottish Office moved into Victoria Quay, built on reclaimed dockland and in a short period of time, Leith was regenerated.

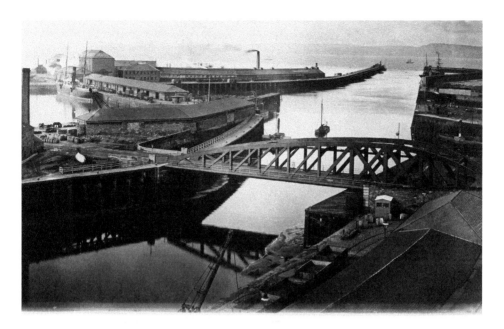

VICTORIA BRIDGE, Leith Docks.
Photo: J.McLean 1895.

Above and below: Bridges

The area to the east of Leith was owned by Logans of Restalrig whilst on the other side of the river, the land had been given to the Abbey of Holyrood in 1128 by David I. In 1493, St Ninian's Chapel was founded by Abbot Robert Bellenden of Holyrood on the west side of Water of Leith; the first bridge was erected at Sandport to allow access to the church and the tolls contributed to the church. The three-arched stone bridge was not replaced until 1788 when it was demolished in favour of a drawbridge, allowing finished boats from the shipyard upstream to sail out of the estuary. A second drawbridge was built in 1800 just downstream from Bernard Street and removed in 1910.

The Victoria swing bridge, built in 1874 to provide road, rail and pedestrian access between Victoria Dock and Albert Dock, was hydraulically operated and at 120 feet, was, at that time, the longest swing bridge in Britain. A modern bridge running parallel to it fulfils traffic-bearing duties now, but the retired swing bridge is maintained and classed as Category A listed building.

Above and below: **Industry and Commerce**

At its height in the late nineteenth century, Leith was a hive of industry, many of the businesses located around the docks, including shipbuilding yards, glassworks, sawmills, sugar refinery, soap-making factories, a distillery and tanneries. The traditional flour mills were superseeded by grand buildings like the steam-powered Chancelot corn mill, which covered 3 acres of land. Although this edifice was burned down, then demolished in 1971, Chancelot built a modern replacement on reclaimed land at the Western harbour.

Ships were built at Leith for five centuries but the best-known shipbuilding company, and last to close (in 1984), was Henry Robb Ltd. During the Depression of the1930s, Henry Robb absorbed the business of its rival, Ramage and Ferguson, when that went into liquidation, creating a yard with nine building berths and five dry docks. The closure was a huge loss to Leith and the local economy, but symptomatic of the wider decline in British industry. Ocean Terminal was built on the site of Henry Robb's.

Edinburgh and Leith Glassworks were situated between Salamander Street and the Leith branch of North British Railway and notable for their conical kilns. Glass production here started in 1746, when the most important product was wine bottles, although later, lead crystal glass for chandeliers was made, eventually becoming a 'brand' in its own right, known as Edinburgh Crystal.

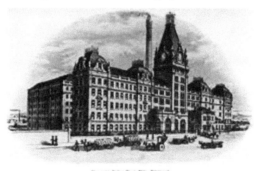

Chancelot Roller Flour Mills, Edinburgh.

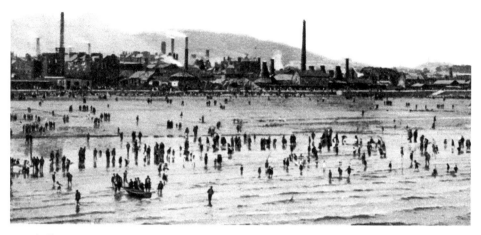

Portobello

Portobello is not shown on early maps; until the eighteenth century, the coastal strip of Figgate Muir was uninhabited, desolate moorland, used only for mustering troops before battles or as a hideout for vagabonds and smugglers. The first recorded dwelling, known thereafter as Portobello Hut, was built by a sailor returning from war in South America in 1742 but within twenty-five years, a settlement had begun, due to a man named William Jamieson who, in 1765, discovered clay deposits around the Figgate Burn and saw the potential for producing bricks and tiles. This enterprising man built two brickworks which operated until the early 1800s when the clay beds were exhausted, and even constructed a small harbour at the mouth of Figgate Burn – although this was not of consequence apart for small craft. Portobello went on to be known for pottery, particularly Thistle Ware. The last pottery closed its doors in 1972.

Joppa, around a mile east of Portobello, was known for its salt pans. The ancient industry used coal from the Midlothian seam as fuel to heat sea water in huge pans and was one of many similar sites around the Firth of Forth. It was centred around the 400-year-old Rock House and the place where the family of future publishers W & R Chambers lived after their weaving business in Peebles went bankrupt, and their father, James, came to work as commercial manager of the salt company. The teenage William, who lived in Edinburgh and was an apprentice book-seller then, wrote about the stinking, smoky atmosphere of Joppa Pans. In the late 1800s, the Scottish Salt Company was formed and did not close until 1953.

The mile-long-stretch of firm, golden sand became popular in the early nineteenth century. It was useful to the cavalry from nearby Piershill Barracks for exercising their horses; a young Walter Scott, who had volunteered for the light dragoon regiment, was reputed to love cantering along these sands. The attractive location drew visitors from the city and from 1800 onwards villas started to be built near to the shore. Then the arrival of the railway in 1844 accelerated development of Portobello as a seaside resort, bringing huge crowds of day-trippers from Edinburgh and the Borders. In 1871, a 1250-foot iron pier was built as an extra attraction. It was designed by Thomas Bouch, who was the engineer responsible for the first Tay Bridge; the latter had an early demise, lasting less than two years, but the Portobello Pier was to last forty-six years, despite requiring a great deal of maintenance. It was particularly badly damaged during storms in 1917, after which it was deemed unsafe and demolished.

In 1933, Edinburgh Corporation drew up plans for a replacement pier, which ultimately did not come to fruition, but the other proposal, for an open-air swimming pool, did. The pool included a novel wave-making machine and proved very popular until the facility went out of fashion in the 1970s. The building was demolished in 1988.

Portobello Pier.

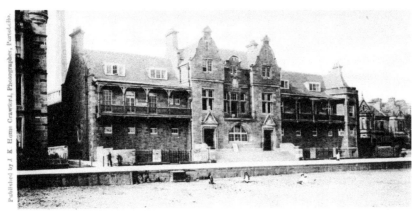

Sea Water Baths.

Lizzie and I are in Porto. for a few days holidays, and are enjoying ourselves immense. Regards J. Paterson —

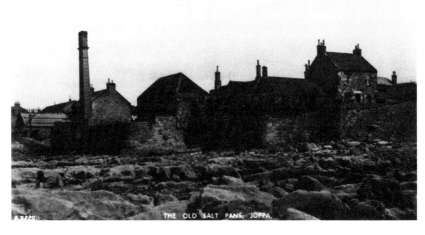

Old Salt Pans, Joppa.